IMAGES
of America

THE JEWISH
COMMUNITY OF THE
NORTH SHORE

During the 1976 American bicentennial, the Jewish Historical Society of the North Shore was founded as a nonprofit, volunteer organization. Its purposes are, among other things, to promote awareness of Jewish history, to encourage scholarly study, and to collect and preserve evidence of this history.

IMAGES
of America

THE JEWISH
COMMUNITY OF THE
NORTH SHORE

Alan S. Pierce and Avrom J. Herbster
for the Jewish Historical Society
of the North Shore

ARCADIA

Copyright © 2003 by Alan S. Pierce and Avrom J. Herbster
ISBN 0-7385-1329-6

First published 2003

Published by Arcadia Publishing,
an imprint of Tempus Publishing Inc.
Portsmouth NH, Charleston SC, Chicago,
San Francisco

Printed in Great Britain

Library of Congress Catalog Card Number: 2003108411

For all general information, contact Arcadia Publishing:
Telephone 843-853-2070
Fax 843-853-0044
E-mail sales@arcadiapublishing.com
For customer service and orders:
Toll-free 1-888-313-2665

Visit us on the Internet at www.arcadiapublishing.com

*Dedicated to the memory of our fathers,
Sidney Pierce and M. Irving Herbster,
and to the fathers and mothers of us all.*

CONTENTS

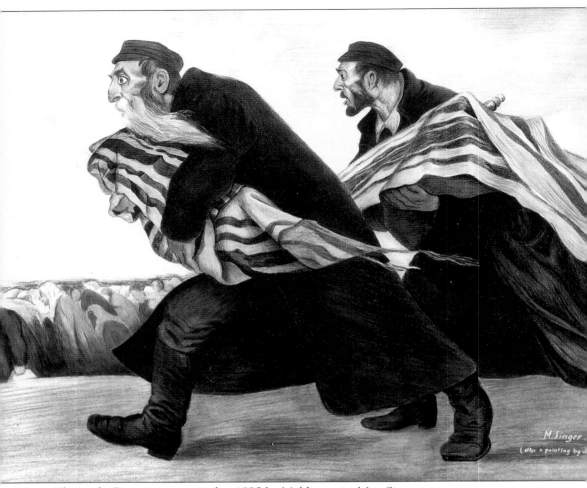

Fleeing the Pogrom was painted c. 1935 by Malden artist Max Singer.

INTRODUCTION

The end of the 19th century saw the flow of immigration from western and eastern Europe to the shores of America. Jewish immigration was noteworthy because many of this religious and ethnic group were not only looking for new opportunity, they were fleeing oppression, discrimination, and the anti-Semitic pogroms of eastern Europe.

Many Jews came to America past the Statue of Liberty, through the gates of Ellis Island in New York, and northward to start a new life with friends and family in the Boston neighborhoods of the West End, Roxbury, Dorchester, and Mattapan. They moved to cities just north of Boston, including Chelsea, Revere, Everett, Malden, and Medford, or a bit west to Cambridge and Somerville. Others, perhaps a bit bolder, ventured farther north, 10 to 20 miles from Boston, and settled in the area known as the North Shore—the cities of Lynn, Salem, Peabody, Beverly, and the towns of Marblehead, Swampscott, and Saugus.

The first wave of Jewish immigration, mainly from Germany in the early to mid-1800s, resulted in a Jewish presence in the large industrial cities, such as New York and Philadelphia, and even popular Southern cities, such as Atlanta and Charleston. Boston was a destination as well, only a short trip from Ellis Island. In the 1880s, the second wave of immigrants believed they would find a better way of life in America, the *goldene medinah*, or "golden land." Jews did come to Boston and other big cities during this time, but there was a slow and steady movement to outlying areas where housing was more plentiful and less expensive. In these largely non-Jewish communities, there were industries or trades where one could find work. If the entrepreneurial spirit and dedication were present, perhaps the new resident could open up a butcher shop or grocery store.

Each of the major cities—Lynn, Salem, Peabody, and Beverly—developed in similar ways; the Jews established neighborhoods, synagogues, community centers, social organizations, and stores. Each of these cities also had its own unique history.

Lynn was the first city on the North Shore to be settled by Jews in the late 1800s, because it was a center of commerce and industry with thriving manufacturing plants that produced shoes and textiles. Lynn, on the ocean, was a short train or trolley ride to Boston, yet it had its own character. It was an ideal place for a Jewish family to grow, and the majority of the early Jews on the North Shore settled here. Lynn prospered until the 1960s, and like many factory towns, it went into a period of economic decline. Many of the former residents of Lynn moved to the smaller but more upscale towns of Swampscott and Marblehead. Lynn is on the upswing, and it

is a city of choice for recent immigrants, many of Hispanic heritages, and there are a number of Asian Americans and recent Jewish immigrants from Russia.

Salem is a city full of history from its Puritan past, to the infamous witchcraft trials, and its maritime history of trade with China and the Far East. Salem in the 1850s was one of the busiest and most famous ports in America. Jews started coming to Salem in the 1880s, and in addition to working in factories and stores in the early years, they became prominent professionals. Salem is the county seat for southern Essex County and became a center of law and commerce. Its popular weekend market was a meeting place for many Jews and other ethnic groups.

Beverly, founded in 1626, is one of the oldest settled communities in Massachusetts. Situated on the ocean, it was always largely a residential town, with a pleasant mix of open space and a manufacturing base for the large United Shoe Machinery plant. Beverly has a strong Yankee heritage, and areas such as Beverly Farms are among the more exclusive places to live on the North Shore. Jews lived in various neighborhoods, and while they never reached as high a population as they did in other cities, they founded synagogues and social organizations.

Peabody, once part of Salem and then South Danvers, was from its earliest days a manufacturing town, and leather was its main product. Peabody was known as "the Leather City" of the world. From the 19th century on, it always had a rich ethnic history. The first Jews settled in Peabody in 1896, and they quickly became involved in leather manufacturing. The first Jews were Ashkenazic, from Russia, Poland, Lithuania, and Germany. They established synagogues beginning in 1909. In the early 1900s, Sephardic Jews from Turkey came to Peabody and established a synagogue that continues today. Jews became merchants and manufacturers. The Jewish community established a community center in 1939, as well as many other social and cultural organizations. In the late 1950s, the leather industry declined, and West Peabody (formerly an area of farmland) began to develop. The Jewish population shifted from downtown to the west. With the building of Route 128, many young engineers from outside the area moved to Peabody and the surrounding towns. Peabody has always had a diverse ethnic population. The tradition of ethnic diversity continues today with many Portuguese, Brazilian, and Hispanic immigrants who live there.

Saugus, although technically on the North Shore, was something of an anomaly. Closer to Revere and Boston, it seemed somewhat apart from the rest of the North Shore. The few Jews who lived in the town were dairy farmers or skilled and unskilled tradesmen.

As noted, Marblehead and Swampscott were more heavily settled after the Jewish population moved from Lynn, Chelsea, and elsewhere. However, there was always a small Jewish population in Marblehead, and there was even a Jewish soldier who fought at a battle in the Revolutionary War. Swampscott and Marblehead have developed into very desirable suburban towns with substantial Jewish populations, who are involved in the commercial, civic, and social lives of the towns. While Swampscott and Marblehead became centers of Jewish life with the establishment of synagogues, a Jewish community center, a day school, and a rehabilitation center, in recent years, the population has shifted farther north and west.

Towns such as Lynnfield, Danvers, Middleton, Topsfield, Boxford, and Manchester-by-the-Sea have historically had few Jews, although that is changing as more Jews are moving in.

The history of the Jewish community of the North Shore has been rich and diverse. We can only speculate what the 21st century holds in store for it. If history is a guide, it should be clear that the Jewish community will continue to play an identifiable, active role in the commercial, civic, cultural, and social fabric of the North Shore.

One
THE EARLY YEARS

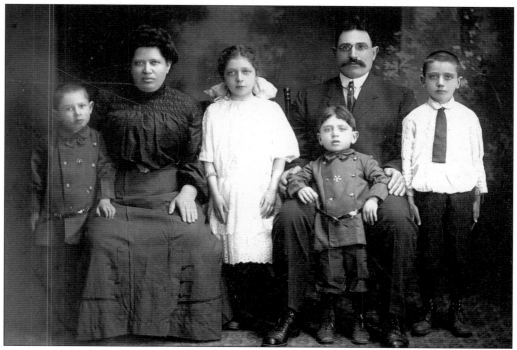

Hannah and Abraham Levin, of Salem, are pictured with their children Sophie, Joe, Sam, and Harry.

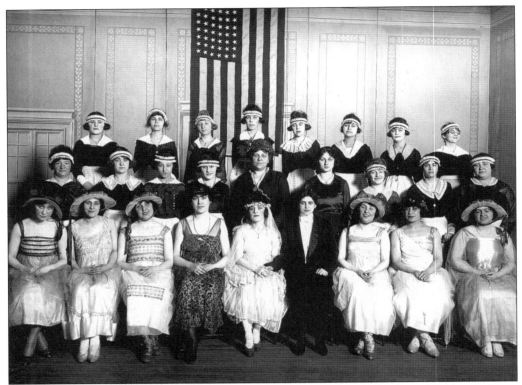

The Lynn YWHA (Young Women's Hebrew Association) Society Show and Dance, held on March 27, 1919, featured a "mock wedding." The YWHA and the YMHA (Young Men's Hebrew Association) provided a wide variety of services to the Jewish community, including Sunday school classes, lectures, athletic, and cultural programs.

The motto of the socialist Sunday school in Lynn was "Each for All—All for Each."

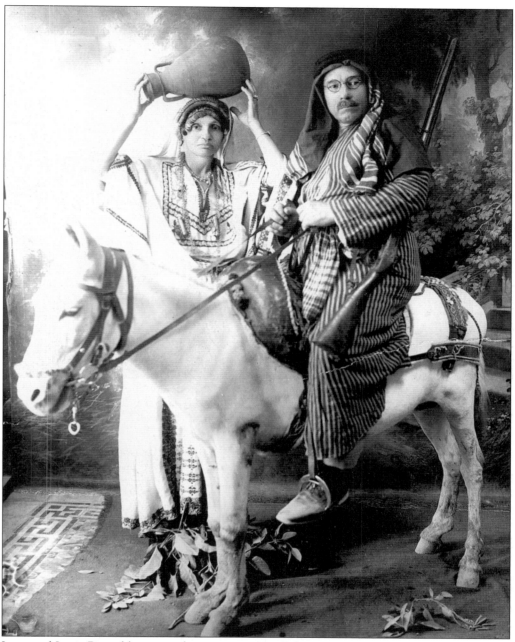

Lena and Louis Rosenbloom are shown on a trip to Palestine in 1928. The Rosenblooms lived on Cabot Street in Beverly, and Louis Rosenbloom owned real estate in the Beverly area.

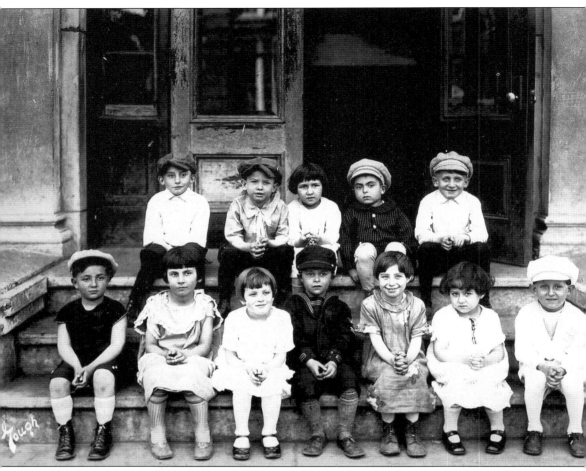

The Lynn Hebrew School class of 1926 poses for the photographer. From left to right are the following: (front row) Irving Rabin, Ann Rosenthal, Ida (Robinson) Grossman, Harold Darish, Alfreda Kaplan, unidentified, and Lou Falkoff; (back row) Max Garber, Alan Madell, Adele Zykofsky, Sidney Grob, and ? Falkoff. (Courtesy Sidney Grob.)

Jay Karelitz, the first Jewish boy to be born in Peabody (1898), later became a businessman and was active in civic organizations.

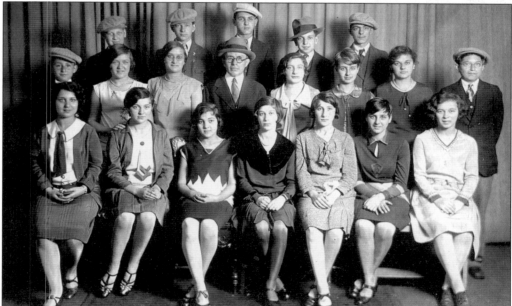

This view shows the Lynn Hebrew School class of 1929. From left to right are the following: (front row) Ann Gershaw, Jeanette Synderman Nadler, Clara Goldman, Sadie Oseransky Weinstein, Sadie Rosenthal, S. Alberg, and Jennie Bellman-Sarna; (middle row) Irving Lions, Jeanette Bender, Ann Bender, ? Schlossberg (principal), Lea Sudnofsky, Freda Raben Feldman, Ida ?, and Louis Brown; (back row) Abbott Sachar, Solomon Feldman, Sydney Ross, Emanuel Greenfield, and Bennie Shaffer.

In 1899, Abraham Sklover and the police chief of Marblehead, Frank Goodwin, stand in front of Sklover's Tailor Shop, on 80 Washington Street in Marblehead. (Courtesy Gil Sklover.)

Jacob Morris, of Salem, is pictured with his daughter Fanny Morris, who later married Samuel Marron, who built many residential homes in Peabody in the 1930s and 1940s.

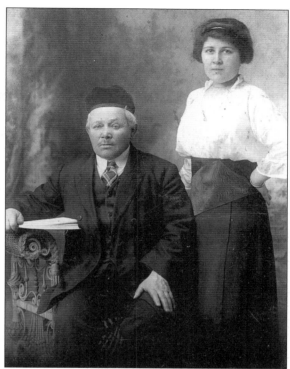

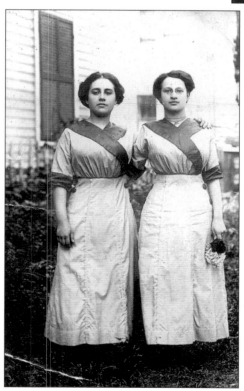

This photograph shows Ruth and Minnie Goldman in 1918.

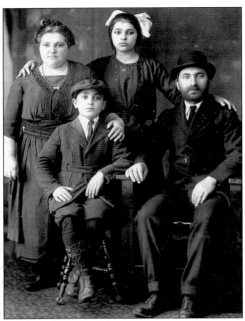

This is the Herbster family in 1920. Family members are Bessie, Ruth, M. Irving, and Solomon Herbster. M. Irving Herbster became a lawyer and was the city solicitor of Peabody from 1962 to 1967. He was a leader of the Peabody Jewish community and the ritual director of Congregation Sons of Israel. He spoke and wrote extensively about Peabody's Jewish history.

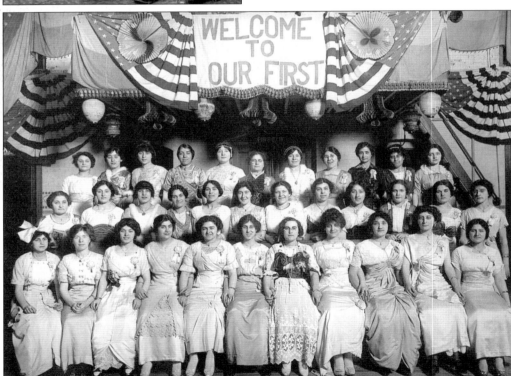

The Lynn YWHA celebrated its first anniversary on January 7, 1914. The YWHA was formed the year before at 120 Market Street in Lynn. Etta Finkelstein, who later married Isadore Freeman, was elected its first president; Sarah Green was vice president; Frances Litvak was treasurer; Doris Zamcheck was secretary.

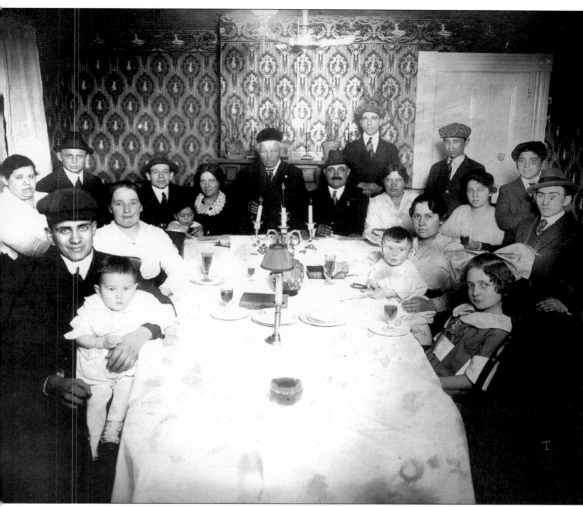

This Passover seder was held in 1918 at the home of Abraham Levin, at 130 Boston Street in Salem. Passover is known as the "feast of unleavened bread." It commemorates the exodus from Egypt. The Haggadah, from a Hebrew word meaning "narration," is read during the seder, from the Hebrew word meaning "order." The meal includes many symbolic foods, including matzo (the Hebrew word for unleavened bread), a shank bone, and bitter herbs known as *marror*.

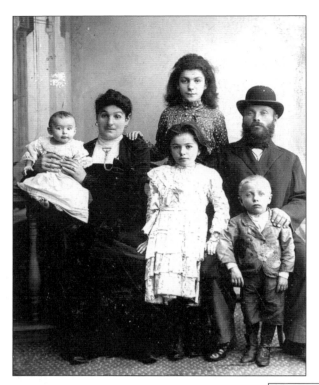

Hiram and Rose Freedman and their children—Ann, Eva, Bess, and Alex—were an early Jewish family of Salem. Alex later ran a hardware store on Front Street.

This photograph shows Robert Scholnick, of 119 Blossom Street in Lynn. Scholnick, a resident of Lynn for 20 years, died at age 108 in September 1927. He was born in 1819 in Vilna, Lithuania. He came to Lynn with his wife, Fannie. He had a daughter, Mrs. Rose Resnik, and three sons, Joseph, Harry, and Louis Scholnick.

This is a wedding photograph of Sara and Max Aronson, of Salem.

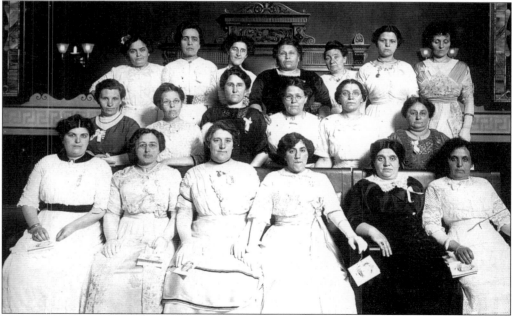

The gala ball of the Lynn Hebrew Ladies' Social Circle was held at the Elks hall in Lynn. More than 400 prominent figures from Jewish circles attended this elaborate event. The committee included Mrs. Isaac Hayes, Mrs. Hyman Levine, Mrs. William Brown, Mrs. David Anson, Mrs. Isaac Jacobson, Mrs. Aaron Atkins, Mrs. John Grob, and Mrs. Harry Lyons.

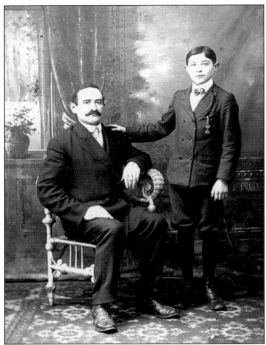

Jacob Edelstein and his son Harris are pictured in 1906. The Edelsteins were one of the first Jewish families in Peabody. Jacob Edelstein was the financial secretary of Congregation Sons of Israel for 40 years.

This is the citizenship certificate of William Fliegel, of Beverly.

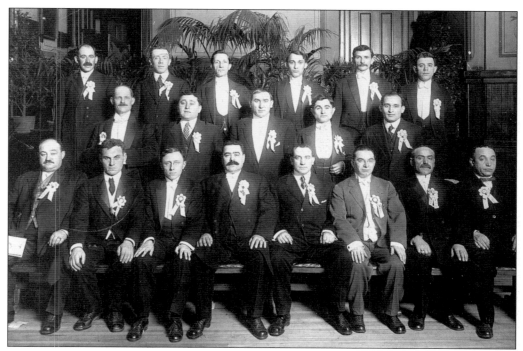

This photograph of the Lynn Independent Order Brith Abraham was taken in December 1914. The organization began as a Jewish men's fraternal order in New York City in 1859. It was organized as a lodge system and provided benefits to its members.

This photograph of the Fliegel family was taken in Marblehead *c*. 1910. From left to right are Barnett Fliegel, Rebecca Fliegel, and Harris (Fliegel) Fladger. The family arrived in Marblehead in the late 1890s and lived at 10 Central Street.

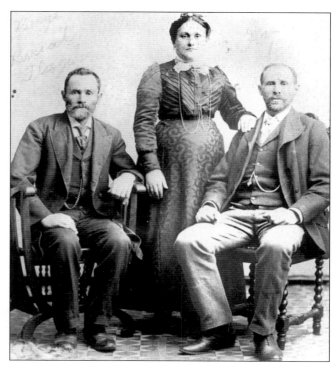

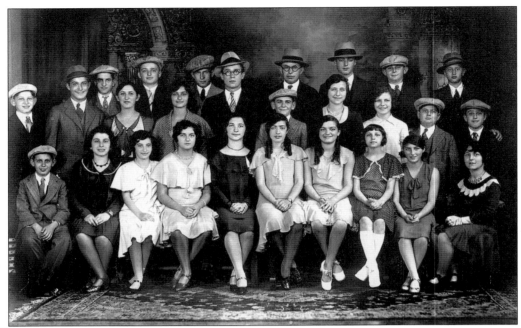

The Lynn Hebrew School class of 1924 poses for the photographer. From left to right are the following: (front row) Milton Millman, Sophie Kimmel, Eva Mesnick, Bea Goldman, Rose Malinow, Sadie Shapiro, Lena Bender, Ethel ?, Ray Samuels, and Ester Gold; (middle row) Sidney Ross, Samuel Zetlan, Sarah Bloom, Ida Smaller, Arthur Rapport (teacher), Joe Engel, Sally Gordon, Helen Katz, Phillip Dansker, and Harold Light; (back row) Aaron Garber, Sidney Lipsky, Joe Rosenthal, ? Schlossberg (principal), Harold Frank, Phillip Goldman, and Max Margolis.

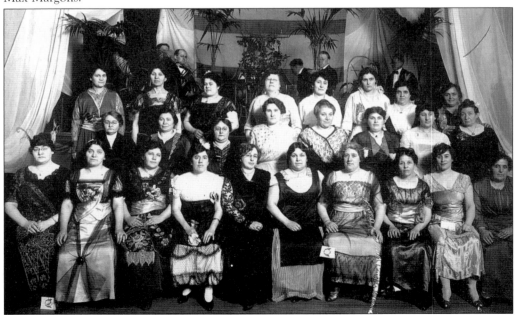

The Ladies' Aid Society of Lynn is shown *c.* 1914.

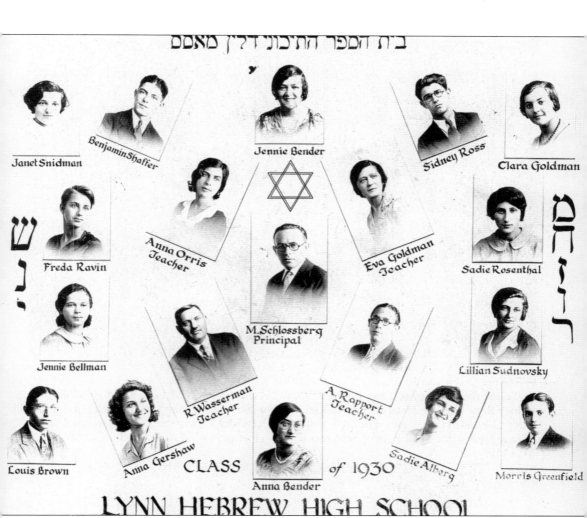

Featured in this montage is the Lynn Hebrew High School class of 1930.

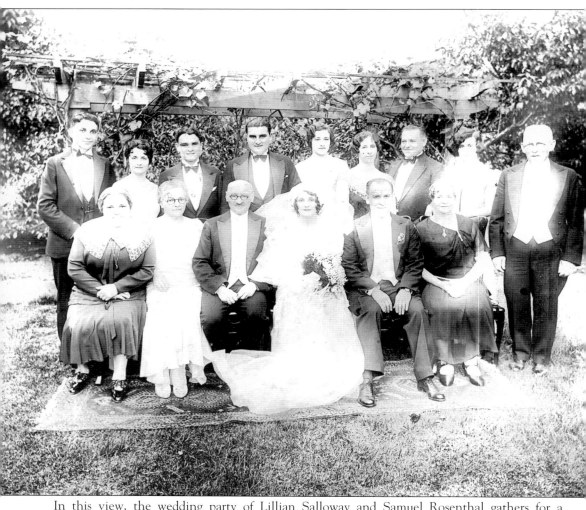

In this view, the wedding party of Lillian Salloway and Samuel Rosenthal gathers for a photograph at the Korn residence on Thorndike Street in Peabody in 1929. The wedding party includes, from left to right, the following: (front row) Bessie Herbster, Rhoda Korn, Max Korn, Lillian Salloway, Samuel Rosenthal, and Mrs. and Mr. Rosenthal (mother and father of the groom); (back row) M. Irving Herbster, Fayne Salloway, Harry Salloway, Michael Salloway, Lola Weissman, Mariam Weissman, Nathan Weissman, and Toni Weissman.

Two

NEIGHBORHOODS AND BUSINESSES

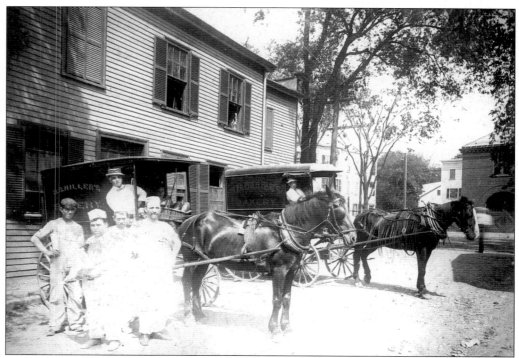

Max Gordon is among the men posing next to the Miller bakery in 1915.

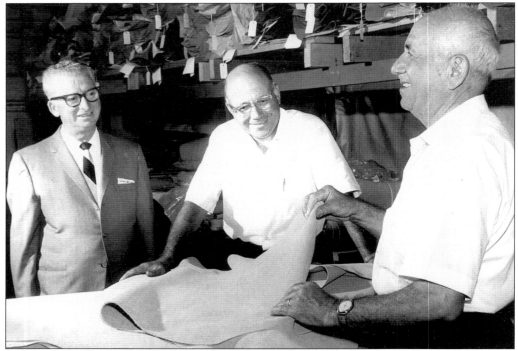

The Fermon Leather Company was in Peabody. Shown, from left to right, are William B. Behar, David Fermon, and Samuel Fermon.

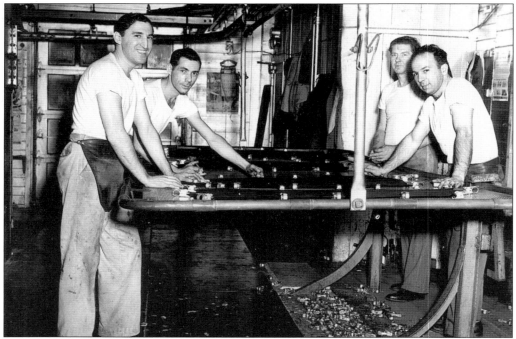

These employees of the Fermon Leather Company are, from left to right, Frank Wisegold, Albert Fermon, Harold McDonald, and Leo Pernitchi.

Peabody, Mass,, _____ 192___

M _____

BOUGHT OF

Louis Karelitz Furniture Co.

COMPLETE HOME FURNISHERS

Carpets, Linoleums, Ranges and Talking Machines

23 CENTRAL STREET

Terms _____ Telephone 84-W

Pres.	Peabody Y M H A Election 10			
	Al Hershegon elected			
Vice Pres	Ed Ankles			
Prege	Morse Kerstein			
F Sec	Jack Karagoolen			
Rec Sec	all Smile			
Pres	miller Lost 12 to 9 votes			
Vice P	Portchiel Lost 12 to 9 "			
Pres	I Lost 12 to 11 "			
	I was nominated for Pres & Vice and Dec Sec			
	" because myie had no opposition Pres I stood			
	Yap Levine demanded a recount			
	because there was 1 vote short			
	miller was opposed to the program			
	I did not care to take the office			
	on account of being to busy futin			

Letterhead from the Louis Karelitz Furniture Company identifies the company's address as 23 Central Street in Peabody. The notes were written by Louis Karelitz's son Jay and refer to a YMHA election of officers.

27

The Sheinheit Slaughter House was located at 22 Walnut Street in Peabody. Jacob "Yankel" Sheinheit operated this business for many years. Peabody was home to kosher butcher shops run by Samuel Ainbinder, Morris Goldstein, and Nathan Goldstein.

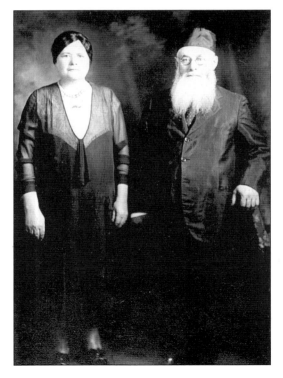

Zelda and Samuel Ainbinder are shown on their 50th anniversary in September 1942. Samuel operated a kosher butchery at 13 Mill Street in Peabody from 1919 to 1949.

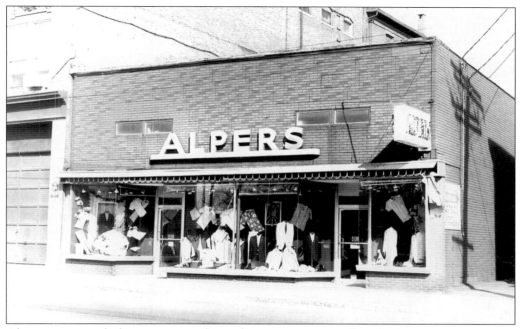

Alper's, a men's clothing store, was located on Foster Street off Peabody Square. There were many Jewish-owned businesses in downtown Peabody, including Tanzer's Blacksmith Shop, Remis Furniture, the Komarin Shoe Store, Sam Pitcoff's Lunch, and steamship travel agencies operated by Charles Halpert and Raymond Bacherman.

The Rosenfel Building is located at 4 Walnut Street at the corner of Central Street in Peabody. David Rosenfel was active in the Popular Credit Union and the Arbeiter Ring (Workmen's Circle), a progressive social and cultural organization. He also became involved in real estate.

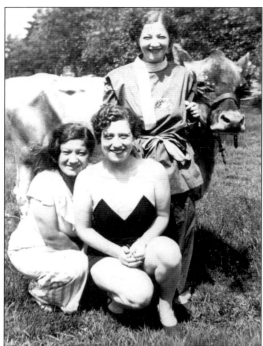

Posing here are, from left to right, Pauline, Rose, and Bertha Goodman. The Goodmans of Saugus were religious Jews who kept kosher, like many Jews of that era. Morris Goodman was a founding member of the Flint Street synagogue in Lynn, which was formed shortly after he and his wife, Bessie, and their three children arrived in America in 1905. Goodman would buy milked-out cows from area farms. When he had enough for a truckload, he would haul them to a slaughterhouse in Brighton. The milk from the milking cows would be purified in the barn behind the house, bottled, and delivered to homes in West Lynn. (Courtesy Bette Wineblatt Keva.)

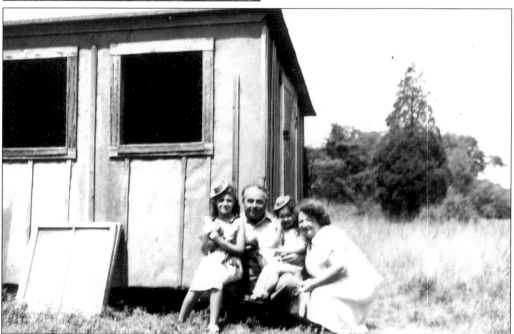

Bertha (Goodman) Finklestein (far right) and her husband, Phillip Finklestein, of Malden, pose with her nieces Martha Weinblatt (far left) and Bette Weinblatt in front of the family's chicken coop c. 1948. Bertha Finklestein was the youngest of six children who lived and worked on a Saugus cattle and chicken farm. Her three oldest siblings—Sam, Jacob "Jack," and Rose Goodman—were born in Russia.

LIST OF JEWISH BUSINESSES
IN THE SUMMER-BLOSSOM ST. AREA

SUMMER ST. 1960

#21-SAM'S TAILOR SHOP
35- ELKIN'S SUPPLY- PLUMBING
41- FACTORY FURNITURE OUTLET
54- LISOOK DRY GOODS
59- TOWN PAINT & SUPPLY
60- BRIGHT STAR STOVE
70- BILL'S SUPPLY CO.
90- ADAM'S LINOLEUM
94- ELM FARM FOODS
99- METROPOLITAN FURNITURE
141- BEN'S RADIO & TELEVISION
152- BARR M & SON FRUIT
157- BROWN'S BARGAIN STORE
162- SLOBODKIN P & CO. MEATS
165- MAURICE GOLDBERG VARIETY
181- LYNN INDEPENDENT WORKMENS CIR CREDIT UNION
182- LABOR CIR CREDIT UNION
191- STROME INSURANCE THEODORE PEARLMAN INS
194- G & E KOSHER MEAT
198- N Y DELICATESSEN
196- LYNN POST 31 2 JEWISH AM VETERANS
205- SHULTZ BROS BARBERS
207- CENTRAL GROCERS
208- SHELDON PHARMACY
210- NEW YORK MODEL BAKERY
211- HYMAN WEISMAN MEATS
213- LESNEVERS PATENT MEDICINE

215- MERIT DRUG
216- CHARLES WEINSHEL MEATS
218- KAY'S DELI
219- BANKS MARKET PLACE MEATS
220- MEZZO'S MARKET MEATS
222- TOBIN EGG STORE
223- CHASE S YARN STORE
225- SAM'S FRUIT STORE
226- DIAMOND SHOE STORE
228- PHILIP SPACK MEN'S STORE
230- NEW ANGLE GLASS
239- LYNN CREDIT UNION
241- M KREPLICK PHYSICIAN
248- BROTHERHOOD CREDIT UNION
249- MAX WHEELER BOTTLING
250- QUALITY BARBER SHOP
252- MORRIS NADLER SHOES
253- STANDARD HARDWARE
260- STONE'S BAKERY
261- ATLAS DELICATESSEN
266- BESSIE RUBIN SHOES
289- ABBOT 1HOUR CLEANERS
291- JULIUS NUSSBAUM PHYSICIAN
317- MORRIS ROITER GROCERS
353- MANUEL SAMUEL GAS STATION
370- CLARENCE LONDON PHYSICIAN

BLOSSOM ST.

79-MELVIN SHAPIRO MEATS..... 83-SAMUEL KLINE MEATS..... 85-SINGER'S POULTRY MARKET...
92-AARON SHULTE PLUMBING ... 38- CONGREGATION BETH JACOB HEBREW SCHOOL

CHURCH ST.

65 - CONGREGATION AHABAT SHOLOM · LYNN HEBREW BENEVOLENT SOCIETY

COMMERCIAL ST.

81- SAMUEL RUBIN PLUMBING 156-HARRY'S LUNCH 180-LYNN LUMBER

This list represents the Jewish businesses in the Summer Street–Blossom Street area of Lynn in 1960. At that time, there still were many Jewish businesses in this area of Lynn. Within the next decade, many of the businesses were gone. Lynn was also a center of commerce. The businesses on Market Street and Union Street included Rooks Department Store, Sam's Town and Tweed Shop, and Hoffman's Department Store.

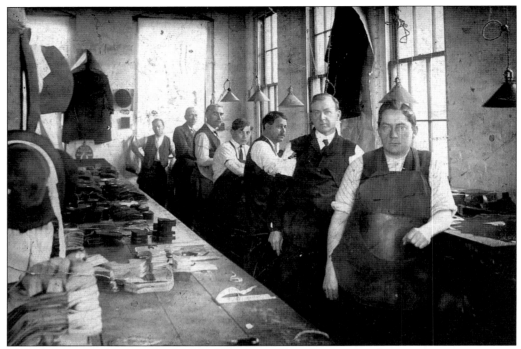

This photograph shows workers at the Weinstein Shoe Company in Lynn.

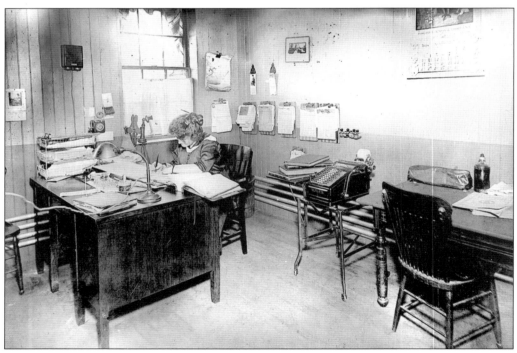

The bookkeeper of the Harry Weinstein Shoe Company works in an office in 1918.

Warren Street in Peabody was one of the residential streets downtown where many Jewish families settled to be near synagogues and factories.

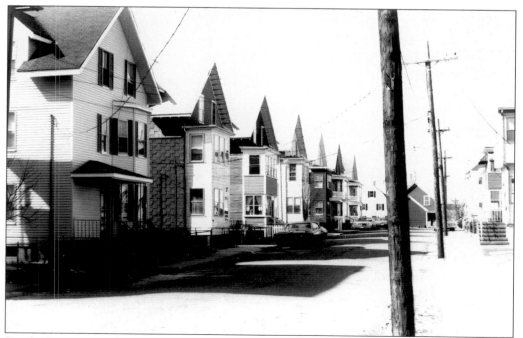

Smidt Avenue in downtown Peabody was also home to many Jewish families due to its proximity to factories and synagogues.

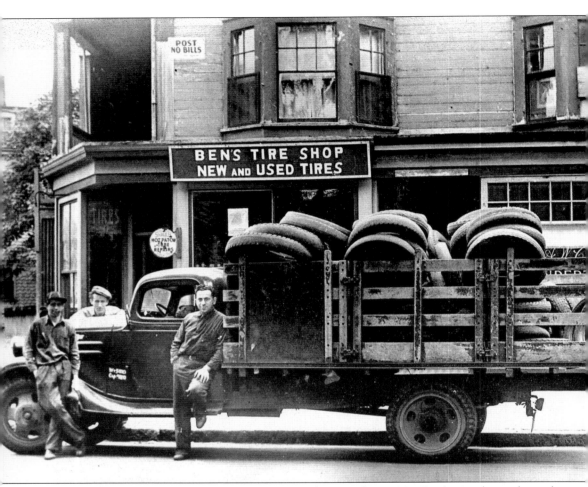

Ben Shore was the proprietor of Ben's Tire Shop in the 1930s. Ben's was located on the Lynnway, near Broad Street, and was a local landmark for 62 years.

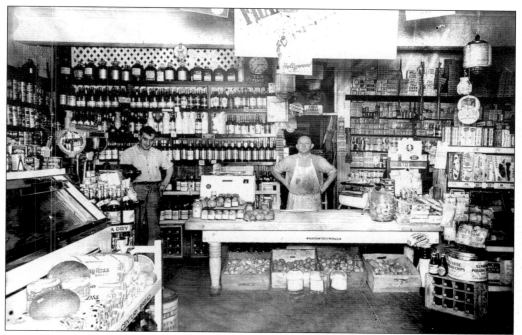

Weisberg Market, located near 30 Central Street in Peabody, served the local community for many years. Many Jewish families lived on or around Central Street in downtown Peabody.

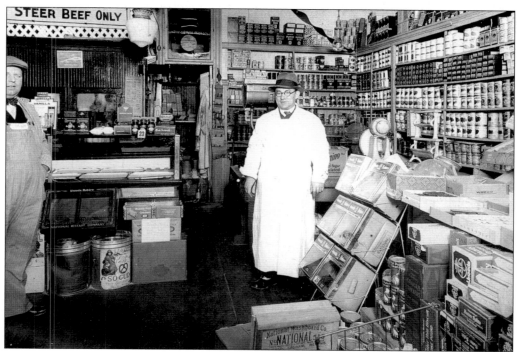

Louis Weisberg was the proprietor of Weisberg Market.

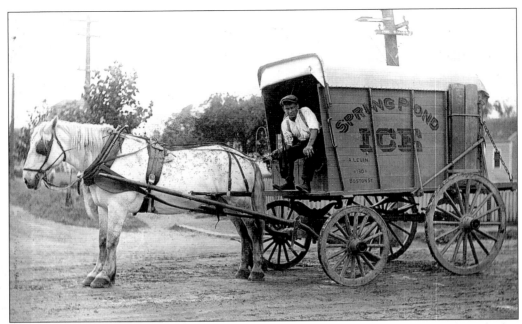

The Spring Pond Ice Company, at 130 Boston Street in Salem, cut ice from South Peabody's Spring Pond. The company was owned by Avrum Levin. Barney Morris is shown here on the horse-drawn delivery wagon.

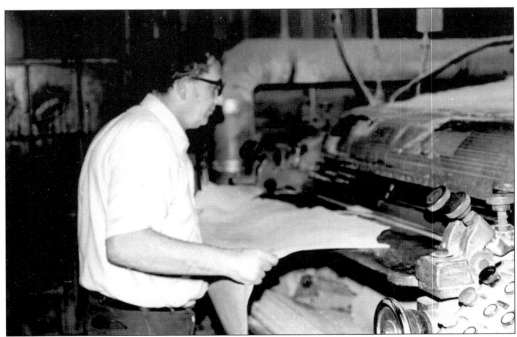

Sidney Pierce, of the Central Buffing Company (72 Central Street in Peabody), operated a buffing machine to prepare leather for the tanning process. This was one of many leather-related businesses operating in Peabody, which was known worldwide as the Leather City.

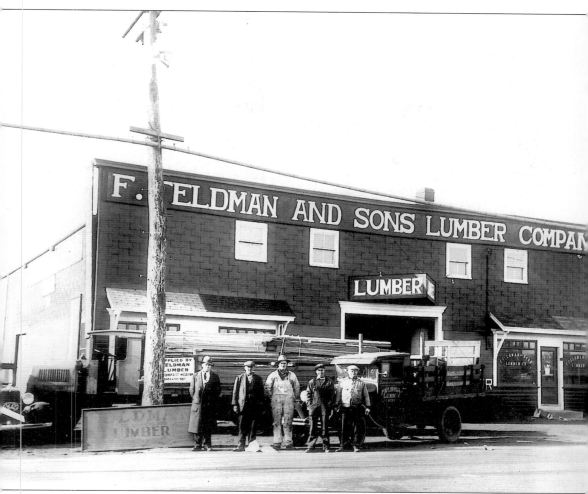

The F. Feldman and Sons Lumber Company was based in Lynn. The lumberyard, located on the Lynnway, was established by Frank Feldman in 1923. It remained in the family until the early 1970s. Frank Feldman had five sons—David, Barney, Solomon, Izzy, and Louie—several of whom were involved in the business. (Courtesy Saul and Doris Feldman.)

Pharmacist Gertrude (Remis) Walmsley is pictured at Quinlan Square Pharmacy, located in Peabody.

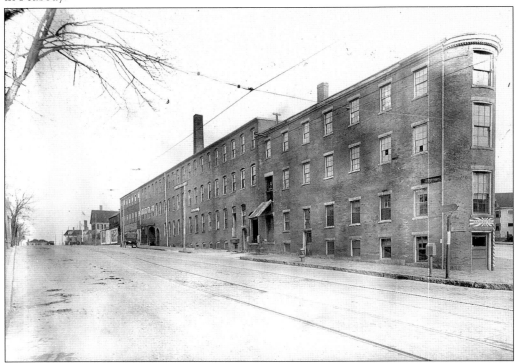

The Peabody Shoe Company was located at the corner of Cabot and Rantoul Streets in Beverly.

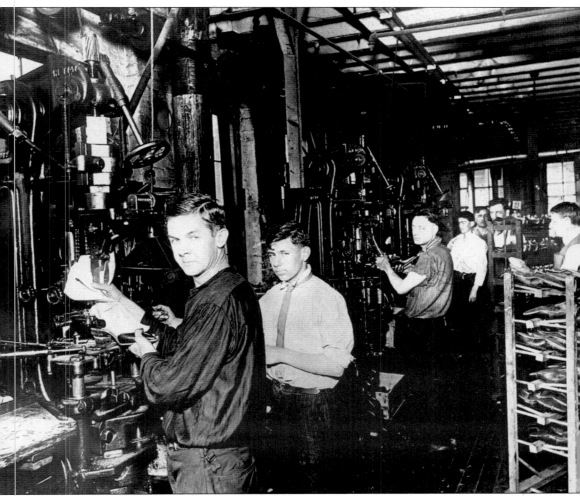

In this view, Albert Singer is seen third from the left near shoe manufacturer A.M. Creighton.

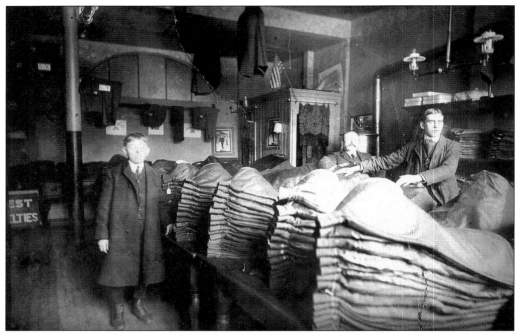

This 1897 photograph shows the New England Supply Company, located on Essex Street in Salem at the site of the present YMCA. Meyer Winer is on the left, and Max Winer is on the right. Max, who moved to Salem in 1885, was the first Jew to settle there.

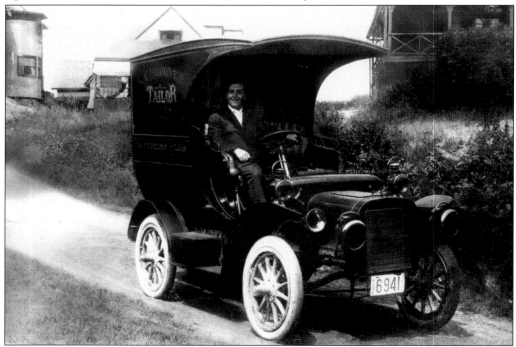

George Chorover was the owner of the first automobile in Swampscott in 1911. He was a tailor with a shop in town, as noted by the advertising on the side of his vehicle.

Three

SERVICE TO COUNTRY

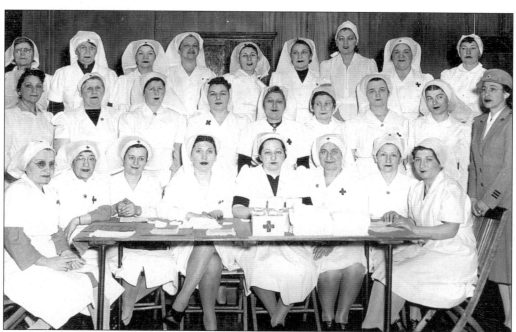

Red Cross volunteer bandage rollers contribute to the war effort at Temple Beth El on Breed Street in Lynn in 1942.

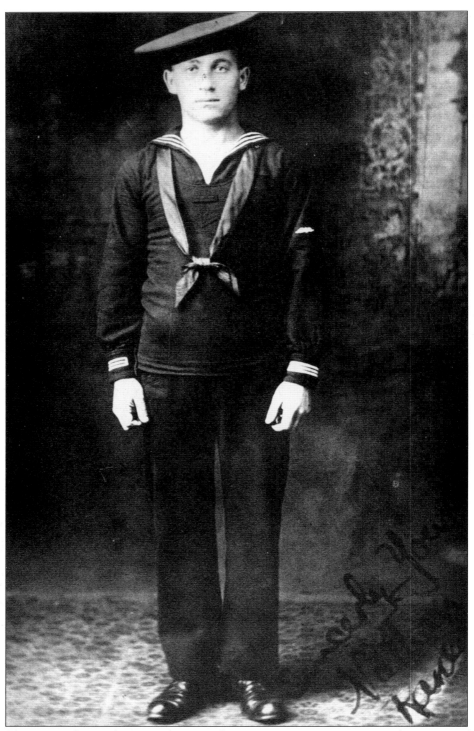

World War I sailor Nathan Ranen, a naval carpenter's mate in 1918, was later an auxiliary police officer in Salem during World War II.

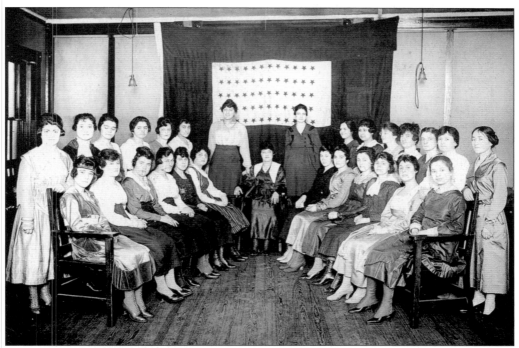

Wives of Jewish servicemen pose *c.* 1918.

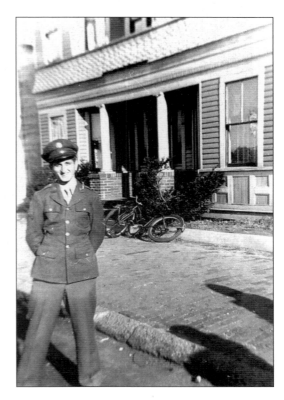

Edward Glichouse, of Beverly, served in
World War II.

This is the army paymaster's roll from June 27, 1775. The Hebrew signature of Marblehead resident Abraham Solomon is the third name down in the left column. (Courtesy the Marblehead Historical Society.)

Dr. Barnett Weinstein, a colonel in the U.S. Army, maintained a general medical practice on Washington Street in Peabody. He spent much of his practice dealing with the illnesses and injuries associated with the leather industry.

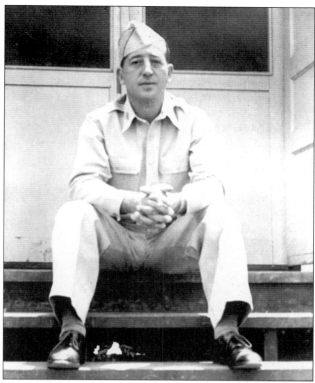

Members of North Shore Post No. 220 of the Jewish War Veterans and Auxiliary pose for a photograph in Peabody. From left to right are Jimmy Green, Milton Kellermann, Joe Salloway, Sarah Wallman, Dora Isaacson, Martin Sulloway, Frances Zoll, Mildred Sulloway, Frances Spatrick, Harry Gardner, Ida Salloway, Annette Lubow, and Mel Lubow.

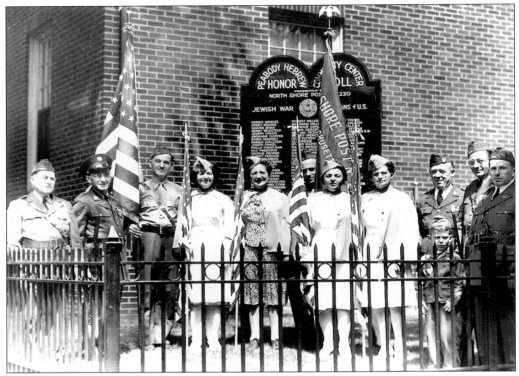

Members of Post No. 220 of the Jewish War Veterans and Auxiliary stand in front of a plaque commemorating Jewish war veterans of Peabody who served in World War II.

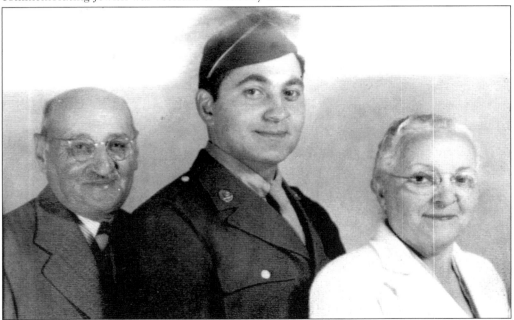

Lt. M. Irving Herbster served in the U.S. Army during World War II. He is pictured on leave from Fort Blanding with his uncle and aunt Max and Rhoda Korn in Florida.

Melvin Zeitlan and his nephew Marshall Hershman served in the U.S. Army in World War II.

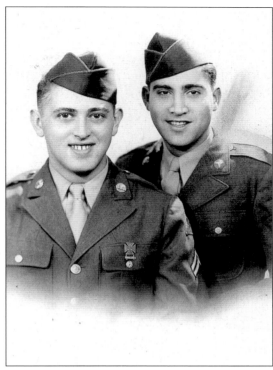

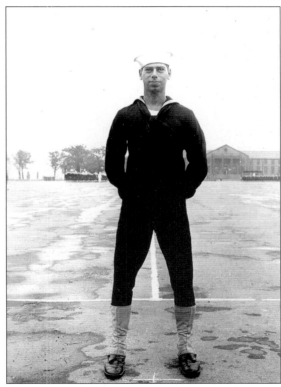

S. Robert Gilberg, an electronics mate for the U.S. Navy during World War II, is shown in this photograph c. 1945. Gilberg grew up in Lynn on Prospect Street. (Courtesy Doris Gilberg.)

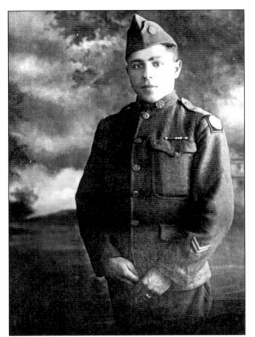

Lewis Kunin, of Lynn, served in World War I.

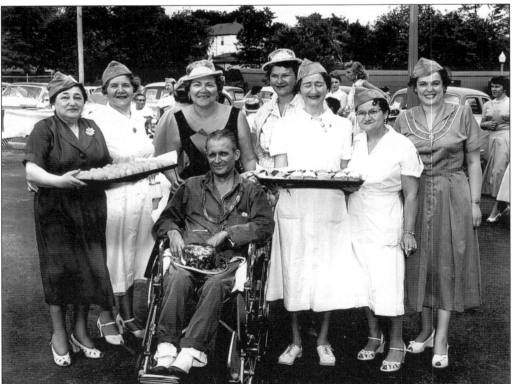

Some of these members of the Jewish War Veterans Auxiliary are Gertrude Boyarsky, Muriel Boyarsky Borash, Ida Razin, and Frances Levine.

Four
RELIGIOUS LIFE

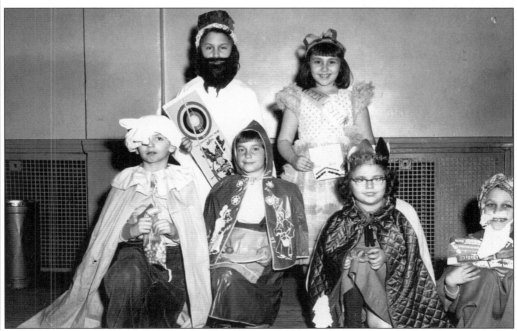

The Jewish Community Center juniors Purim party was celebrated at the Jewish Community Center of Greater Lynn, at 45 Market Street in Lynn. Purim is a festive holiday where children customarily dress as various biblical characters, including Queen Esther and Mordecai.

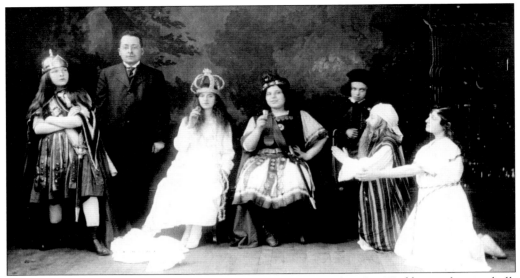

On March 31, 1918, the Peabody Hebrew School put on a play, *Bar Kochba,* at the city hall. From left to right are Alice Komarin, ? Locke (teacher), Sadie Sogoloff, Lillian Bernstein, Morris Rosen, Rose Rubin, and Jenny Salata. The Bar Kochba rebellion took place from 132 to 135 C.E. Sixty-two years after the Temple in Jerusalem burned, Emperor Hadrian of Rome proposed the construction of a new temple to the Roman god Jupiter on the site of the former Jewish Temple. This prompted Simon Bar Kochba (*bar kochba* means "son of a star") to lead a Jewish rebellion. It took a concerted effort by Rome's army to quell the uprising.

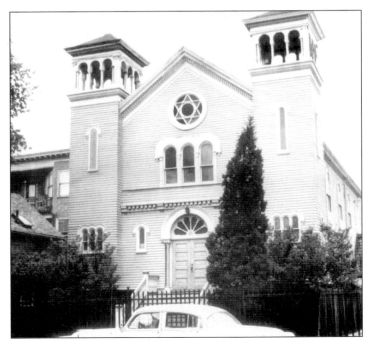

Congregation Ahabat Shalom was originally known as the Litvishe Shul when it was founded by Simon Weinberg in Lynn. Weinberg, born in Poland in 1825, arrived in Lynn in 1855. His name is the first Jewish name to appear in the Lynn city directory. He lived with his wife, Hannah, and their three children at 209 Washington Street and operated a dry goods store at 6 Market Street. (Courtesy Nathan Gass's *The Jews in Lynn: A Retrospective.*)

$ _____ No. _____

Congregation Sons of Israel

INCORPORATED, DEC. 1909.

COR. ELLIOTT PLACE

Peabody, Mass., _____ 191___

To all Persons to whom these Presents shall come, greeting:

THIS INDENTURE CERTIFIES

That Mr. _____

of _____ County, _____

has bought _____ seat No. _____ in the Synagogue

of the above-named Congregation for _____

_____ Dollars

on conditions as the Rules and Regulations of the above-named

Congregation govern the sale of seats.

Witness our hand and seal this _____ day of

_____ 19___ , for the Congregation.

_____ Pres.

_____ Sec.

This deed for two seats at Congregation Sons of Israel is dated October 1916. The seats were issued by Samuel Rossen, president of Congregation Sons of Israel, to Samuel Komarin of Peabody. The importance of regular attendance at synagogue services is underscored by the sale of "deeded" seats.

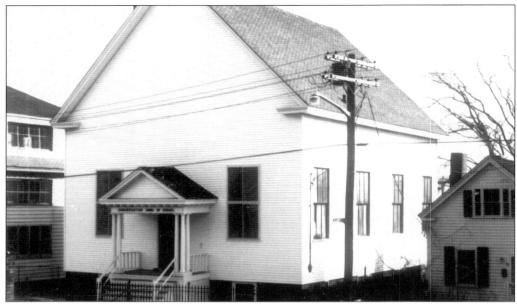

Congregation Sons of Israel was established in 1909 as the first Jewish house of worship in Peabody. Located at Park and Spring Streets, the building was dedicated in 1913, and the congregation remains active today. Although it began as an Orthodox synagogue, in 1962 it introduced mixed seating. It is now a traditional, unaffiliated synagogue. This building was commonly referred to as "the Big Shul," and Congregation Anshe Sfard, around the corner on Littles Lane, was referred to as "the Little Shul."

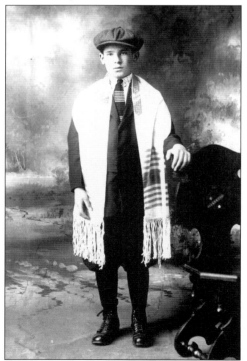

This photograph shows a bar mitzvah boy c. 1920. A bar mitzvah, the Hebrew words meaning "son of the commandment," represents a young man's entry into religious manhood at age 13. A bar mitzvah ceremony occurs when a young man has reached the proper age, has completed the requisite study, and is given the honor of being called to the Torah during a service. Young girls have also been accorded the same honor and become bat mitzvahs, or "daughters of the commandment."

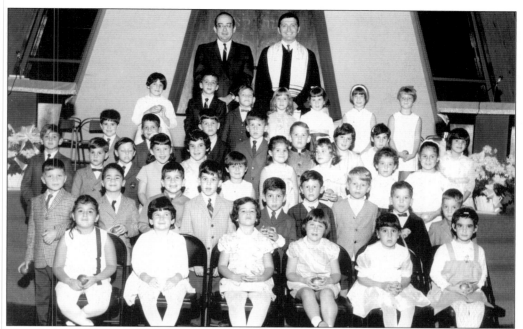

This photograph shows a consecration class at Temple Beth Shalom in Peabody. Temple Beth Shalom was organized in 1960 by 15 families who saw the need for a Reform temple. The dedication ceremony, which took place in December 1965 at 461 Lowell Street, was attended by Congressman William Bates and Mayor Edward Meaney, among many other dignitaries. Rabbi Howard Greenstein was the temple's spiritual leader.

The Temple Beth El religious school is shown at its original location, on Breed Street in Lynn. When Temple Beth El moved to Swampscott, the Hebrew school moved with it. The Hebrew school and Temple Beth El remain active today.

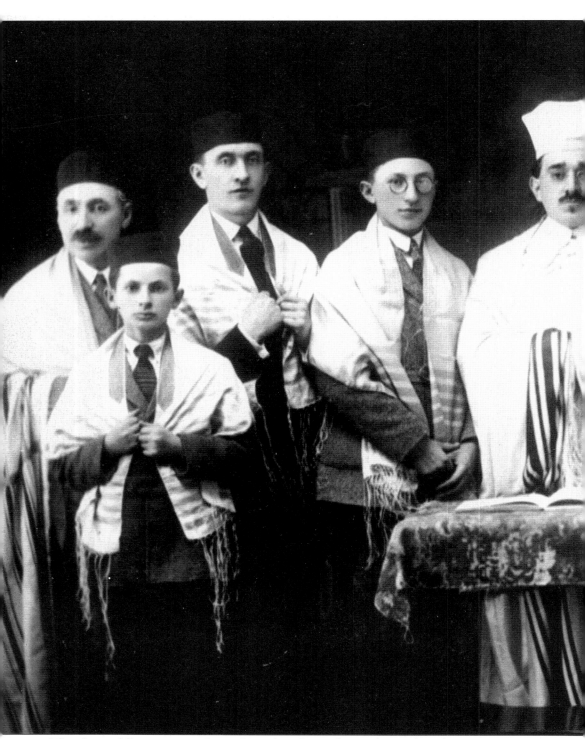

The choir of Congregation Sons of Israel performs during the High Holy Days in 1926. The choir members are, from left to right, David Lecker, Benjamin Erlich, Julius Weisman, Samuel

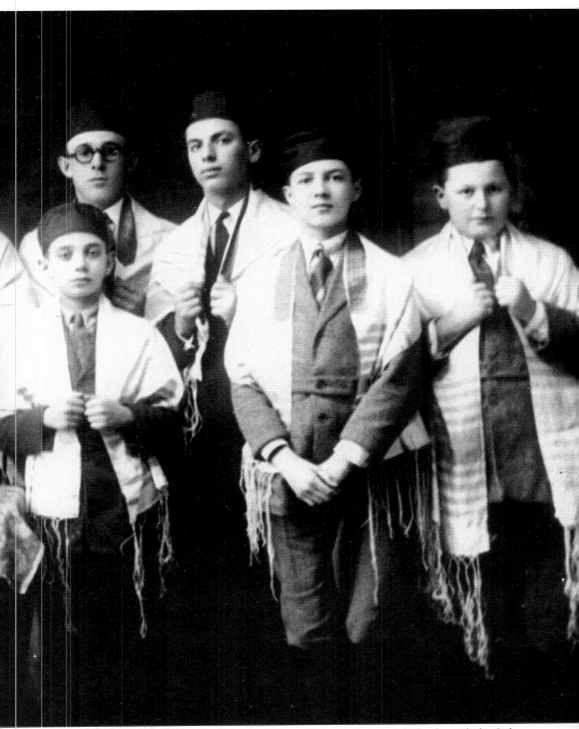

Lecker, Cantor Maurice Ordman, Hyman Millstein, Morris Isaacson, Charles Erlich, Sidney Altshuler, and Nathan Singer.

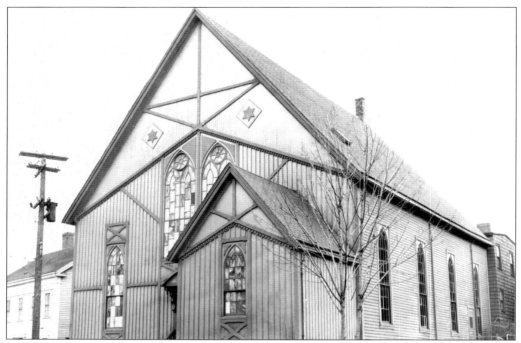

Congregation Sons of Jacob, the oldest synagogue on the North Shore, was incorporated in 1898. It was located on the corner of Essex and Herbert Streets in Salem.

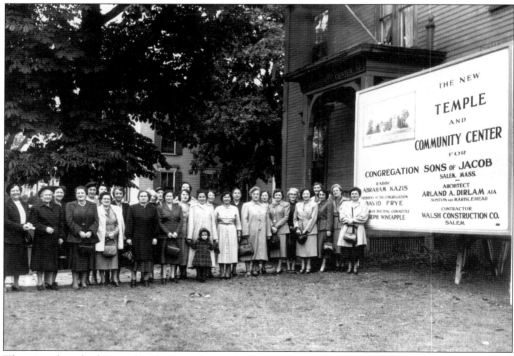

The sisterhood of Temple Shalom, formerly Congregation Sons of Jacob, is shown in 1950 at the site of the new building at 287 Lafayette Street in Salem.

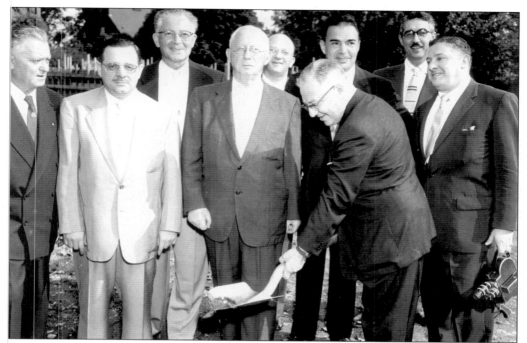

Some of the attendees for the groundbreaking for Temple Israel in Swampscott are, from left to right, Herman Rafey, Harry Simon, Nathan Aronson, Harry Cohen, Isra Andelman, President Hyman Karp (with shovel), John Rimer, Phillip Butman, and Dr. Nathan Gilbert.

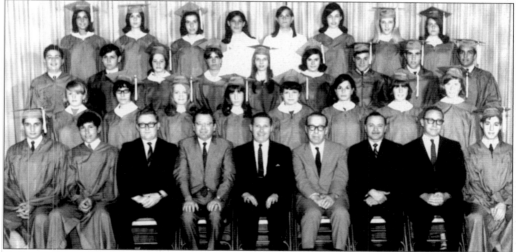

A Swampscott Hebrew High School confirmation class poses on June 13, 1967. From left to right are the following: (first row) Larry Gold, Ronald Weener, Leo Arnfeld (faculty), Nachum Sherf (faculty), George Marcus (principal), Rabbi Peretz Halpern, Cantor Harry Lubow, Jack Aronson (faculty), and Richard Dinkin; (second row) Joanne Bregman, unidentified, Nancy Insuik, unidentified, Nina Ostrovitz, Karen Breitman, unidentified, and Diane Lubovsky; (third row) Gary Gilberg, Alan Samiljan, Bonnie Epstein, unidentified, unidentified, unidentified, Mark Rosen, Barry Shapiro, and Gene Stamell; (fourth row) unidentified, unidentified, unidentified, Linda Schwartz, Amy Rudolph, Regina Lipsky, unidentified, and Ellen Stahl.

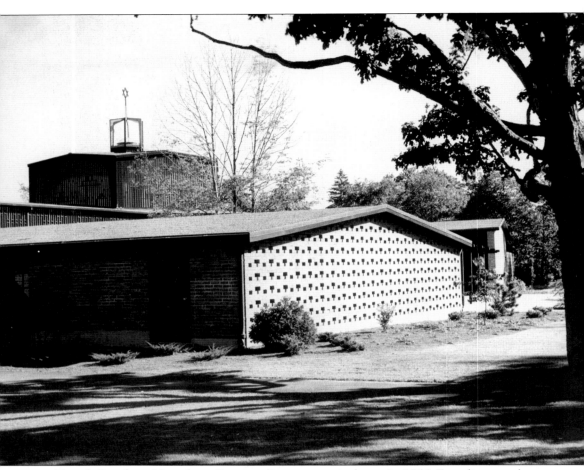

Temple Israel, on Humphrey Street in Swampscott, is shown in 1956. Founding members met at the home of Mr. and Mrs. Eli Cohen in July 1946. In September of that year, High Holy Day services were held for the first time at the Odd Fellows Hall in Swampscott. The temple's first piece of real estate, the First Meeting House, was dedicated in January 1947, and in June of that year, a groundbreaking ceremony was held for the construction of the first part of the temple. In June 1955, after a fundraising effort, groundbreaking was held for the temple's sanctuary.

This photograph shows Beverly's Bow Street Shul, known as Congregation Sons of Abraham. It was formed in the early 1900s by 13 members of the Beverly Jewish community, who met in a hall at 71 Rantoul Street. In 1911, this property (at 37 Bow Street) was purchased. Two separate dedications took place for the *shul* and the Hebrew school, the first in the summer of 1913 and the second on March 8, 1914.

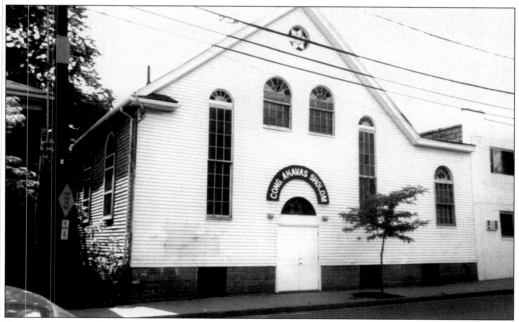

Congregation Ahavas Shalom, established in 1925, was located at 343 Central Street in Saugus. The building was paid for in 1945, and a ceremony was officiated by Rabbi Herman J. Bick and Cantor Abraham Moss. In the 1950s, there were enough Jewish families to establish their own Hebrew school. The building remains an active synagogue serving the small but dedicated Saugus community.

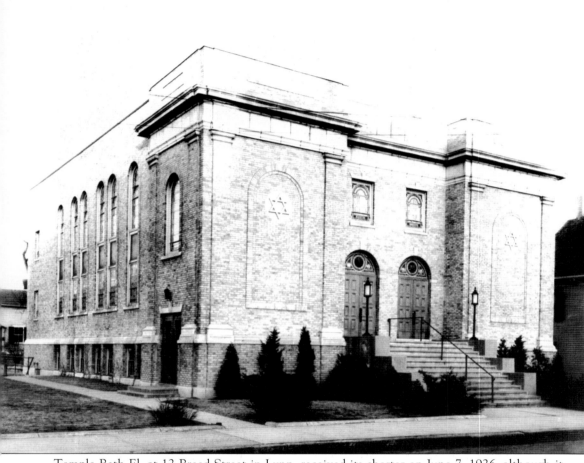

Temple Beth El, at 12 Breed Street in Lynn, received its charter on June 7, 1926, although it originally maintained evening services at the Lynn YMHA quarters. High Holy Day services were held in rented halls. The first service at the 12 Breed Street location was held in 1927. In 1965, during the presidency of lawyer Joseph Kalikow, the property at 55 Atlantic Avenue in Swampscott was purchased and a fundraising effort was begun under the chairmanship of Dr. Harry Parker. Leonard Rosenberg was chairman of the planning committee, and David H. Smith was vice chairman of financing. George Katz and Harold Hoch were co-chairs. Horace B. Strauss was secretary, William Rafael was overseer, and Louis B. Frisch was coordinator. (From the writings of Clarence S. Freedman, historian Temple Beth El.)

The 1954 confirmation class of Temple Beth El in Lynn is shown here. From left to right are the following: (front row) Stephen Price, Gerald Benjamin, Marilyn Dolinsky, Rabbi Israel Harburg, Carol Pearlman, Ira Hayes, Mark Katzman, and David Garber; (back row) Benjamin Cohen (principal), Mrs. Phillip Price (class instructor), Melvin Leshner, Allan Gardner, Joyce Feinstein, Robert Follick, Norman Swartz, Melvin Hershenson (school committee), and Cantor Morton Shanok.

The confirmation class of the Temple Beth El religious school is shown in 1962. From left to right are the following: (front row) Barbara Korenbritt, Nancy Risman, Sandra Cohen, Lois Goldman, Jo-Anna Landsman, Susan Browne, Aileen Swartz, and Sandra Germain; (middle row) Joseph Kalikow (chairman of the school committee), Cantor Morton Shanok, Maxine Price, Judith Stark, Rabbi Steven Schwarzschild, Anita Burke, Ellen Michaelson, Clarence S. Freedman (president), and Benjamin Cohen (principal); (back row) Norman Erlich, Michael Saxe, Charles Leyton, Edward Orris, Allan Farber, David Himmelstein, Neil Strauss, and Barry Dorfman.

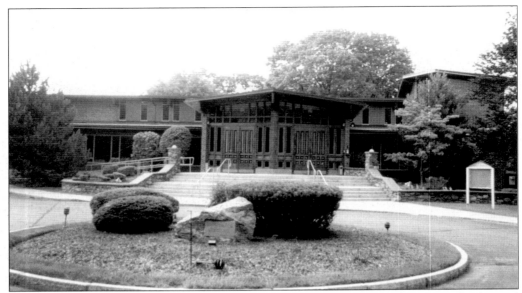

The Reform congregation of Temple Emanu-el is one of the largest in the area and is located on Atlantic Avenue in Marblehead. It maintains a popular Hebrew school and provides many programs for its congregation and the Jewish community at large.

Temple Sinai, at 1 Community Road in Marblehead, was formally dedicated on December 2, 1953, and the temple's religious school held its first confirmation in June 1954. In September 1955, the temple hired Rabbi Dov Zlotnick and Cantor Charles Lew. Groundbreaking for the new temple building off Atlantic Avenue was held on June 5, 1960. One year later, on June 4, 1961, the first event held at the new temple, a religious school graduation, was conducted. Temple Sinai celebrated its 50th anniversary in 2003, and it remains a thriving Conservative congregation.

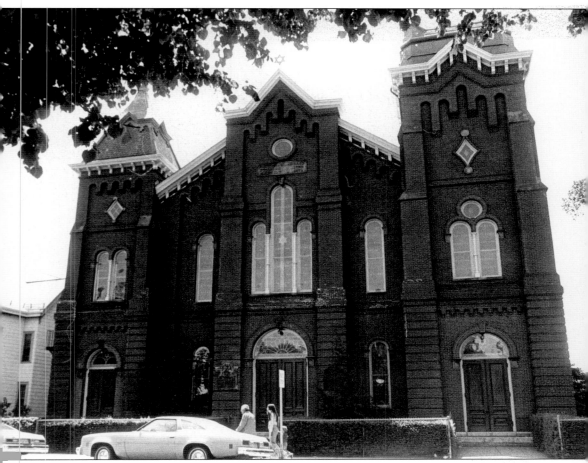

Congregation Anshai Sfard, on South Common Street in Lynn, was one of the many active synagogues in Lynn prior to its dissolution. In 1999, the *shul* donated a Torah to the Jewish Rehabilitation Center for the Aged of the North Shore. Two Torahs were also donated to the Chabad Lubavitch of the North Shore in Swampscott.

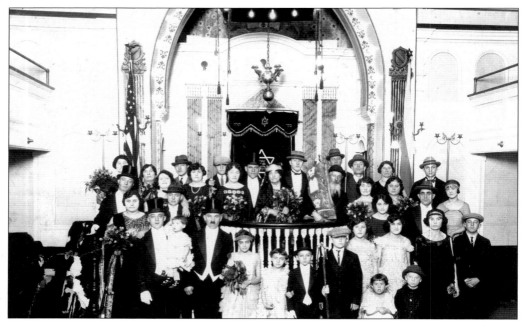

A group poses *c.* 1922 at the celebration for the 50th wedding anniversary of Rachel and Haskel Garfinkle. The event was held on the bimah of the old Anshai Sfard *shul,* located on the corner of Commercial and South Common Streets in Lynn. Congregation Anshai Sfard was established in 1919. Among the founding members were Max Taitsman, Samuel Levine, David Freemerman, Saul Chalek, and Sam Galis.

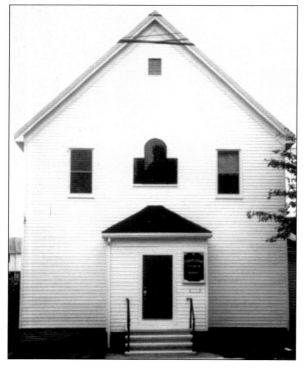

Congregation Tifereth Israel was established in 1922 and is now located on Pierpont Street in Peabody. It is the North Shore's only Sephardic congregation. Its original members came to this country from Constantinople, Turkey, to work in the leather industry.

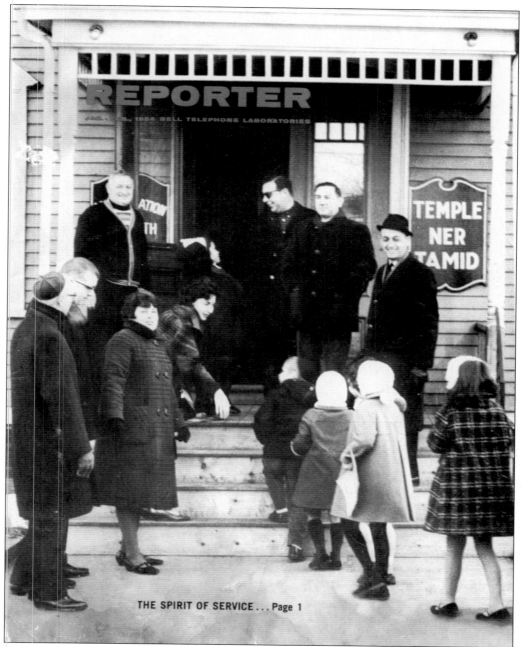

This photograph shows an early location of Temple Ner Tamid in Peabody. Services were held at different locations, including this location at Temple Tifereth Israel, until a permanent home was built off Lowell Street in Peabody.

To His Honor the Mayor and Board of Alderman and Common Council of Beverly Mass.

July 30. 1907

Gentlemen

We wish to extend to you a most cordial invitation to be present at our first Anniversary exercises of the Congregation Sons of Abraham to be held on Sunday August 4th 1907 at 5 P.M. at Burnham Hall 129 Cabot St.

Edward R. Specter Pres.

F. Kranefus

This invitation from the Congregation Sons of Abraham was extended to the mayor and the alderman of the city of Beverly for the first anniversary exercises of the congregation. The event was to be held on Sunday, August 4, 1907.

This photograph from June 1941 shows a Temple B'nai Abraham confirmation class. From left to right are Sally Ann Cohen, Gloria Goldberg, Enid Weinberg, Rabbi Meyer Finkelstein, unidentified, Naomi Berman, and unidentified.

The dedication of Torahs, at Congregation Sons of Abraham synagogue on Bow Street in Beverly, took place on September 7, 1947. Rabbi Abraham Besdin is shown in the foreground, with Mrs. Jacob Sterman, wife of the synagogue's oldest member. The Rubenstein brothers—William, Phillip, Max, Joseph, and Lawrence—are carrying the Torahs.

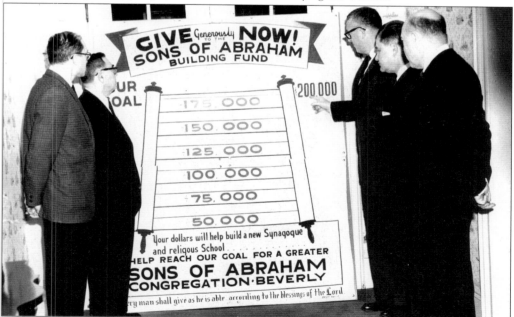

Temple B'nai Abraham established a building fund for the construction of a new sanctuary, auditorium, religious school, and social center on East Lothrop Street in Beverly. Committee members are, from left to right, Jack Weisman (president), Abraham Glovsky (honorary chairman), Sam Kransberg, Max Rubenstein, and David Gordon.

The groundbreaking ceremony for the new home of Temple Beth El, at 55 Atlantic Avenue in Swampscott, was held on October 23, 1966. Shown, from left to right, are Bea Rosenfield, Lyle Rosenfield, and Dora Israel. Construction began on March 1, 1967, and the synagogue was dedicated on September 8, 1968.

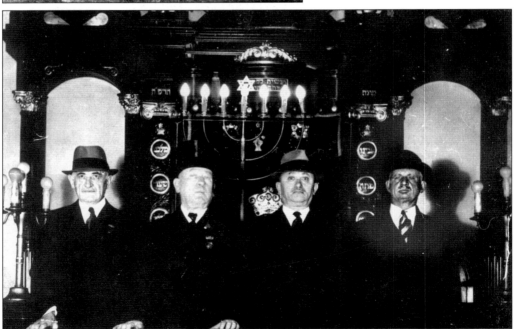

In this c. 1925 view, officers of Congregation Sons of Israel in Peabody are, from left to right, Barney Rubin (recording secretary), Harris Goldberg (treasurer), Samuel Rossen (president), and Jacob Edelstein (financial secretary). They are standing on the bimah, or altar, a beautiful example of traditional synagogue architecture.

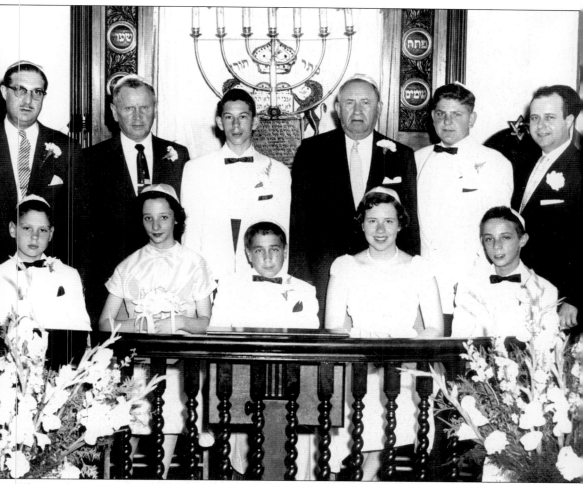

The graduating class of Peabody Hebrew School is shown at Congregation Sons of Israel c. 1956. From left to right are the following: (front row) Norman Ainbinder, Rose Levy, Joe Scholnick, unidentified, and Paul Levy; (back row) Allen Levy, Morris Shiffman (principal), Shep Remis, David Kirstein, unidentified, and Rabbi Dr. Noah Goldstein.

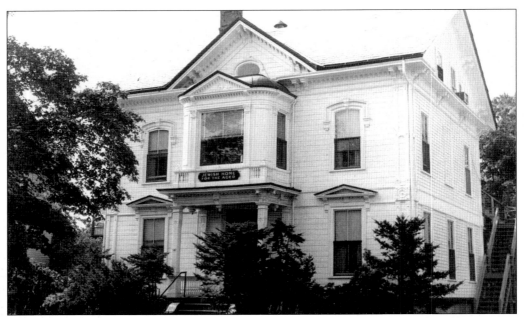

This is a photograph of the original home of the Jewish Home for the Aged. Rabbi Herman Bick, of Congregation Anshai Sfard, formed a committee in 1944 to find a suitable home for the elderly. A 14-room house, located at 147 Washington Street in Lynn, was selected for the home. The dedication was held on October 7, 1945, and among those present were Gov. Maurice Tobin and Mayor Arthur Frawley. The home soon outgrew its limited space; in the mid-1960s, a search committee recommended the purchase of six acres of land on Paradise Road in Swampscott. Groundbreaking ceremonies were held on November 1, 1970, and the new geriatric center opened its doors in Swampscott on March 17, 1972.

The 40th anniversary of Congregation Anshe Sfard in Peabody was celebrated with a presentation to David Kaplan, president, on February 6, 1955. The attendees featured in this photograph are, from left to right, Frank Fleishman, Jacob Grab, Samuel Schneider, Stanley Webb, David Wallman, Saul Tanzer, David Kaplan, and Joseph Lerner.

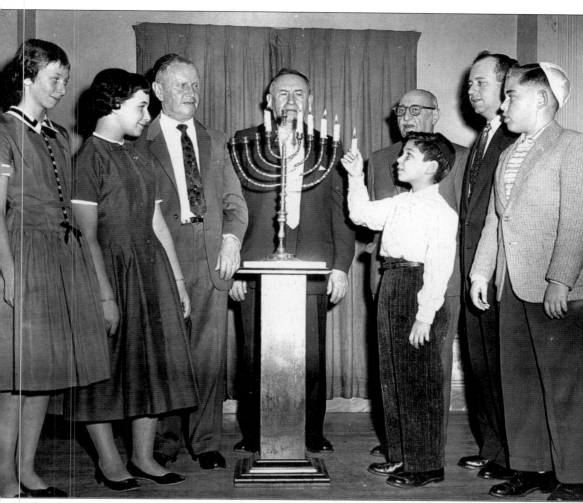

This photograph shows the lighting of the menorah (Hebrew candelabrum) at Peabody Hebrew School in 1958. Those present include, from left to right, Susan Raffer, Sheila Remis, Moishe Shiffman (teacher), David Kirstein, Max Korn, Rabbi Dr. Noah Goldstein, Dan Woloshen, and Edward Shapiro. Hanukkah, known as the Festival of Lights, is celebrated for eight days. This holiday commemorates the Jewish struggle against religious persecution in 167 B.C.E. A candle is lit the first night and each night thereafter, with each lighting accompanied by traditional prayers.

The Temple Beth El Glee Club poses in April 1962. Club members are, from left to right, as follows: (front row) Claire Spielberg, Eva Glickman, Anne Damsky, Ann (Sontz) Segal, Leona Levitt, Mae Kessler, Fayga Lodman, and Beatrice Shanok; (middle row) Ed Lipman, Margaret Stark, unidentified, Lillian Eigner, Zelda Cushner, Marilyn Rooks-Dorfman, Selma Huberman, Hedy Weiss, and Cantor Morton Shanok; (back row) Morris Tabb, Ben Millman, Harry Pollner, Mitchell Lerner, William Needleman, Sidney Novak, Sam Tanzer, and Maynard Orris.

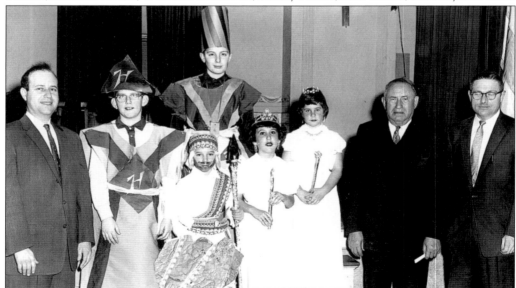

In this c. 1960 view, Peabody Hebrew School students in Purim costumes pose with Rabbi Dr. Noah Goldstein, David Kirstein, and Eli Olasky. Purim, the Hebrew word meaning "lots," is a celebration that includes the reading of the Megillah, or "Scroll of Esther," and children dressed in costumes representing the characters in the story.

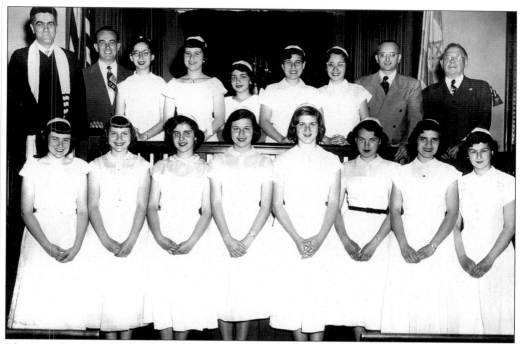

This is a photograph of a confirmation class of Temple Shalom in Salem. From left to right are the following: (front row) Jane Chandler, Evelyn Baker, unidentified, Leanne Kessler, Sheila Marcus, Nancy Smith, Barbara Alpers, and June Townes; (back row) Rabbi Abraham Kazis, Muriel Baker, Rosalie Ablow, Eleanor Kaplan, June Ablow, Esther Margolis, ? Leiberlis, and David Frye.

Congregation Anshe Sfard

קאנגרעניישאן אנשי ספרד

Littles Lane פיבאדי, מאסס. Peabody, Mass.

_____ 19 ____

Dear Brother: :ווערטהער ברודער

אייערע שולדען זיינען:

 Your balance to date:

This is a photograph of a dues statement from Congregation Anshe Sfard, otherwise known as the Little Shul, formerly located on Little's Lane in Peabody. The *shul* existed from 1914 to the late 1970s. The Ark and Memorial tablets are now located at Congregation Sons of Israel.

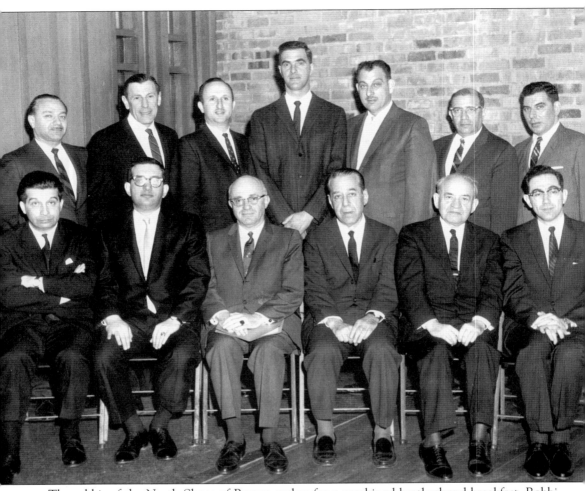

The rabbis of the North Shore of Boston gather for a combined brotherhood breakfast. Rabbi Roland Gittelsohn was the featured speaker.

Five

ORGANIZATIONS

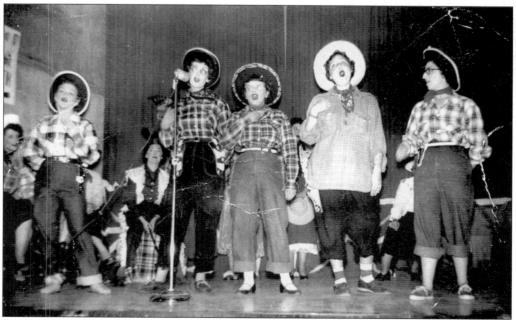

The Lynn B'nai Brith variety show features, from left to right, Arlene Glosband, Marion Young, Marilyn Dobrusin, Mimi Milamed, and Ethel Schultz.

ABIE'S IRISH ROSE

A COMEDY IN THREE ACTS

By
ANNE NICHOLS

Coached and Directed by
MISS LOUISE BLUMBERG

The Cast in Order of their Appearance:

MRS. ISAAC COHENEunice Herwitz

ISAAC COHEN Norman S. Kurman

DR. JACOB SAMUELSPaul Allen

SOLOMON LEVYHarold Goodman

ABRAHAM LEVYNorman Bendixon

ROSE MARY MURPHYLilyan Pearlstein

PATRICK MURPHYOscar Robinson

FATHER WHALENAbraham Sloan

MAID OF HONORRosella Gould

BRIDESMAID Helen Freedberg

BRIDESMAID ... Pearl Garber

— SYNOPSIS OF SCENES —

ACT I
Solomon Levy's apartment, New York

ACT II
Same as Act I — one week later

ACT III
Abie and Rose Mary's apartment, New York
Christmas Eve — one year later

The Intefor Club program for the production of *Abie's Irish Rose* on March 22, 1944, is "to benefit Camp Simchah." The Intefor Club of the North Shore was made up of a group of college-age men who formed the organization in 1931 dedicated to be of service to the community. The name Intefor stood for "intercollegiate forum." The members raised money by putting on dances, as well as plays and musical comedies. In addition to providing funds for the summer camp, scholarships were given to many deserving Jewish students going on to college. From 1931 to 1981, close to $200,000 in scholarships was provided.

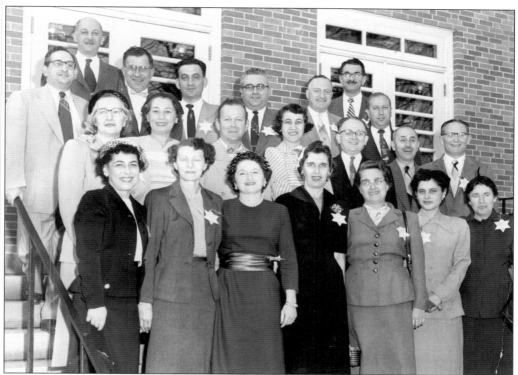

Shown here are delegates from the Jewish Welfare Board of Lynn at the 43rd Annual Convention New England Section, in Manchester, New Hampshire, in November 1953.

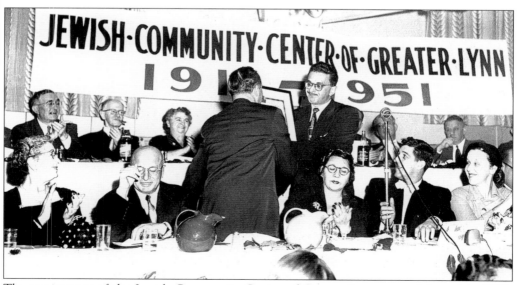

The anniversary of the Jewish Community Center of Greater Lynn was celebrated in 1951. Shown, from left to right, are Marian and Charles Goldman, Sophie Cohen, and Bertha and Barney Bloom.

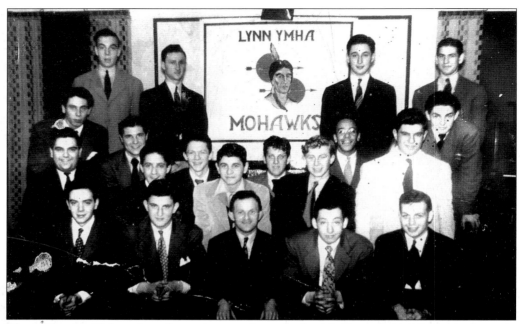

The Mohawks Club gathers for a photograph at the Jewish Community Center in Lynn in 1941. Club members are, from left to right, as follows: (front row) Bernie Schultz, Gordon Winer (advisor), Irving Miller, Harold Barr, and Sidney Strome; (middle row) Leo Spielberg, Abe Phillips, Bernie Berk, Dave Shadoff, Curley Peretsman, Harold Shumrack, Earl Feldman, Max Sherman, unidentified, Fred Kaufman, and Herb Chandler; (back row) Harold Giller (advisor), Nate Hymson, Frank Goldman, and Milt Imber.

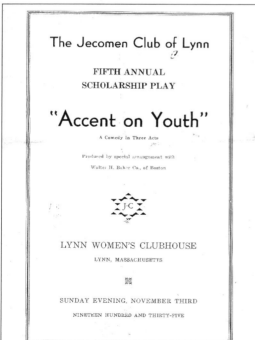

The Jecomen Club of Lynn scholarship play program for *Accent on Youth* was held in 1935. The Jecomen Club, founded in 1925, was a social-cultural organization of young Jewish men, 21 years of age or over, who had attended or were attending institutions of higher education that granted recognized degrees in the arts, sciences, or professions.

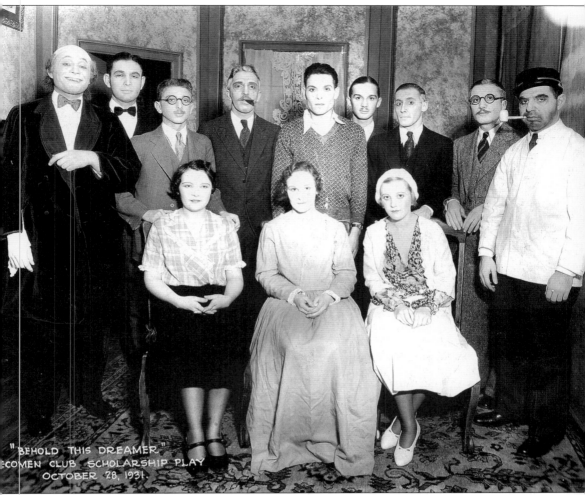

Behold This Dreamer, a Jecomen Club scholarship play, was performed on October 28, 1931.

THE JECOMEN CLUB

presents

"GOLD IN THE HILLS"

or, "THE DEAD SISTER'S SECRET"

A New 19th Century Melodrama in Three Acts
By J. FRANK DAVIS

Produced by special arrangement with Walter H. Baker Co. of Boston

Under the Direction of Miss ESTHER SOLAR

and with the following distinguished

CAST

(in the order in which they appear)

Speaker of the Prologue Mr. NATHAN GOODMAN
LIZZIE JONES, a housekeeper ... Miss ADA ZIEFF
BARBARA STANLEY, Nell's younger sister Miss ESTHER CHOROVER
HIRAM STANLEY, an honest farmer Mr. ISRAEL BLOCH
NELL STANLEY, his daughter Miss ROSE LITCHMAN
JOHN DALTON, a son of the soil Mr. HERVEY L. SOLAR
RICHARD MURGATROYD, from the city Mr. HAROLD W. GOULD
SAM SLADE, his shadow Mr. BARNET L. ROSENTHAL
JENKINS, a constable Mr. LOUIS G. SACHAR
A DERELICT ... Mr. NATHAN GASS
BIG MIKE SLATTERY, a dance hall proprietor Mr. S. WILLIAM STANTON
PETE THE RAT .. Mr. HARRY SAFRAN
OLD KATE ... Miss SYLVIA DORESS
LITTLE TOMMY Master LEON BURNSTINE
THE PROFESSOR Miss GERTRUDE SOLAR
MAMIE ... Miss ANN NADLER
CHUCK CONNORS, a Bowery guide Mr. LOUIS LIPMAN
REGINALD VANDERLOP, an uptown swell Mr. DAVID KUNIAN
Mrs. VANDERLOP Miss JEANETTE LAMKIN
EDITH VANDERLOP Miss MIRIAM GANZBERG
Mrs. GLUE, a sightseer Miss ROSE KREISSER
IZZY, a waiter Mr. LOUIS G. SACHAR
ROSE ROBINSON, songstress Miss LIBBY BURNSTINE
HER GIRLS Misses SELMA AXELROD, FRANCES LYONS
THE DANCIN' KIDS Misses ALBERTA GAUTREAU, FRANCES CALLUM

Synopsis of Scenes

Act I—The Old Homestead; June.
Act II—Big Mike's Beer Garden and Dance Hall on the Bowery; October.
Act III—The Old Homestead again; The following Christmas Eve.

The cast of the Jecomen Club presents *Gold in the Hills*. Every June, the Jecomen Club awarded scholarships to two worthy boys from Lynn English and Lynn Classical High Schools, who would be entering college in the fall. The club produced annual plays or dances to raise money to establish a scholarship fund. The Jecomens remained an independent body that selected its membership based upon character, scholarship, and leadership.

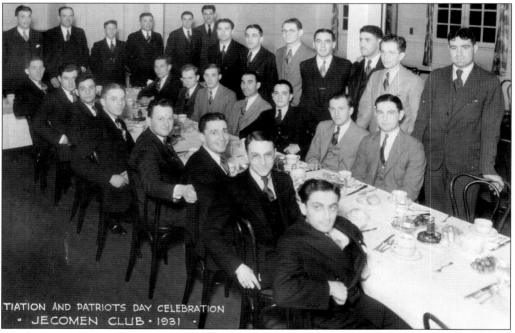

The Jecomen Club is shown in 1931. The club members are, from left to right, as follows: (front row) Harvey Solar, Samuel Bluestein. Irving Kalikow, George Kline, Max Schwartz, Frank Letterman, Harry Safran, and Max Gorodnitzky; (middle row, seated) Mark Lipman, Daniel Rubenstein, Myron Freedman, D. Michael Goldberg, Samuel Sherman, Nathan Gass, and Louis Sachar; (back row, standing) Abraham Viner, Israel Bloch, Jacob Finkle, Benjamin Rower, Frank Levine, unidentified, Nathan Goodman, Arthur Sugarman, Jacob Fox, Louis Zetlen, Henry Zack, and William Stanton.

This photograph shows Workmen's Circle Branch No. 940 in Peabody in 1939. The Workmen's Circle, known as the Arbeiter Ring in Yiddish, is a national, progressive, social, and cultural organization that was founded in 1902. It has been a strong supporter of trade unionism, and its members have included many secular Yiddishists. It reached its apex in the 1930s in Peabody and also operated a popular Yiddish *schule*, or school, that many girls attended.

The Ladies' Helping Hand Society was formed in 1906 on Blossom Street in Lynn. Annie Rapoport, president, presents Rabbi Samuel J. Fox with funds the society raised for an orphanage in Israel. Rapoport was president of the society for 10 years and raised funds for local synagogues. Pictured along with Rabbi Fox are Rabbi Samuel Zaitchik and Cantor Miller. The Helping Hand Society was one of several charitable organizations of the time, including the Ladies' Hebrew Circle, a club devoted to helping the needy and infirm, and the Menorah Society, founded in 1912.

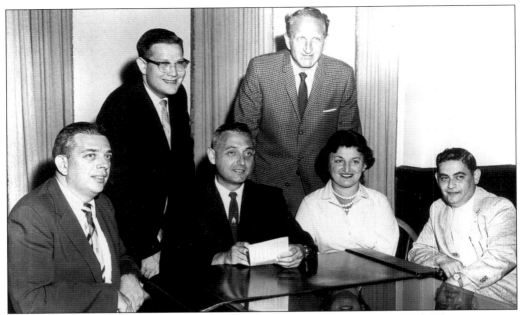

This photograph shows an early committee forming at Temple Ner Tamid. The committee members are, from left to right, Mel Lampert, unidentified, Leon Steiff, Alvin Cherney, Beth Cohen, and Suky Fromer.

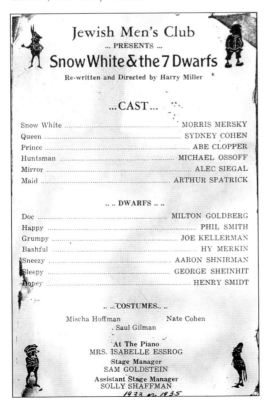

This program for *Snow White and the Seven Dwarfs*, from the Jewish Men's Club in Peabody, dates from *c.* 1933.

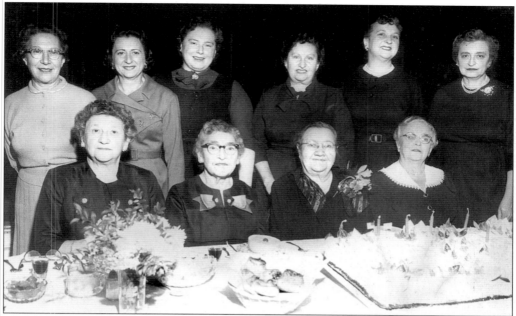

The Beverly Hebrew Ladies' Aid Society held its 50th anniversary celebration on December 5, 1957, at the Hebrew Community Center on Bow Street. The past presidents and current society members are, from left to right, as follows: (front row) Mrs. Maurice Katz, Mrs. Bessie Cohen, Mrs. Helen Grushky, and Mrs. Yetta Morse; (back row) Mrs. Harry Goldberg (treasurer), Mrs. Jack Bernstein (vice president), Mrs. Louis Tanzer (secretary), Mrs. A. Louis Cohn (president), Mrs. William Fliegel, and Mrs. Hyman Bernson.

Members of the B'nai Brith lodge of Lynn are shown at the Concord Hotel in the Catskills. Featured in this photograph are, from left to right, the following: (front row) Dr. and Mrs. Herbie Ross, Sadie Rosenthal, and Esther Rich; (back row) Mrs. and Mr. Teddy Isaacson and Mr. and Mrs. Louis Sherman.

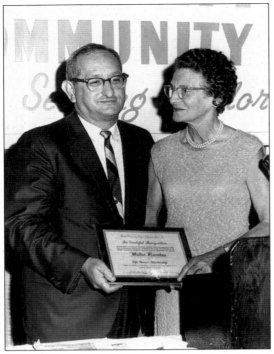

Harold Goodman presents a certificate of recognition to Molly Fierston at the Jewish Community Center of Greater Lynn in 1951.

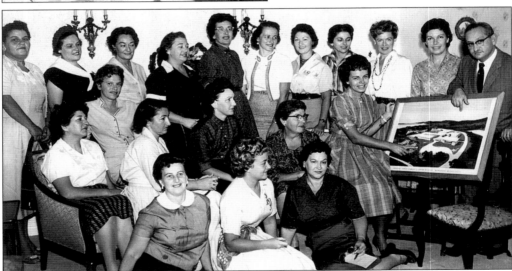

In this 1959 view, the Women's League Committee reviews a sketch for the new Jewish Community Center to be located on Community Road in Marblehead. Those attending are, from left to right, as follows: (front row) Helen Tenebaum, unidentified, Natalie Hotz, Bernice Cushing, Tobey Bell, Esther Goldbaum, Charlotte Mazonson, Ida Blumberg, and Elaine Simons; (back row) Ida Sneirson, Frances Levine, Winnie Ansin, Leah Carver, Lucille Benson, Selma Siskind, Ruth Freedman, Ruth Farber, Polly Glosband, Sylvia Brown, and Harold Goodman. A fundraising program began in earnest in 1966 under the leadership of John Rimer, Marvin Meyers, Harold O. Zimman, and Samuel Stahl, and a groundbreaking ceremony was held on Sunday, October 19, 1969.

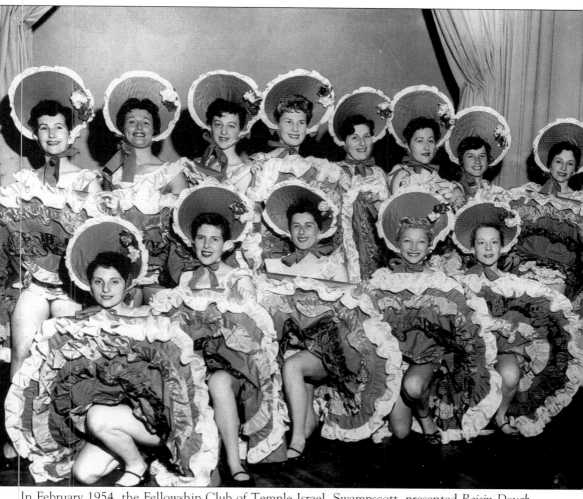

In February 1954, the Fellowship Club of Temple Israel, Swampscott, presented *Raisin Dough* in Swampscott to "raise" money.

Lynn B'nai Brith women pose in 1951.

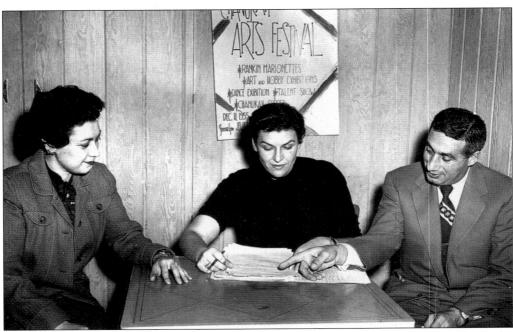

In this December 1955 view, Mrs. Ezra Saul, Mrs. Harold O. Zimman, and Ralph Reback, the Hanukkah Arts Festival co-chairman, are shown at the Jewish Community Center in Lynn.

A cabaret sponsored by the Jewish War Veterans was performed in Beverly in February 1954. Shown in this photograph are Lil Cohn, Marion Fleigel, Esther Stelman, Tillie Goldberg, Syd Weinberg, and Sara Berman.

This photograph was taken during the 50th anniversary of the Young Men's Hebrew Association of the Lynn Jewish Community Center. From left to right are Minnie Pine, Molly Fierston, and Ida Blumberg.

Mayor Arthur Frawley of Lynn signs a proclamation for Women's American ORT (Organization for Rehabilitation and Training), which provides funding for schools in Israel to teach skills and trades. Pictured with Mayor Frawley are Lila Musinsky, Marion Lappin, Phyllis Schutzer, Marci Lampert, and Mildred Poland.

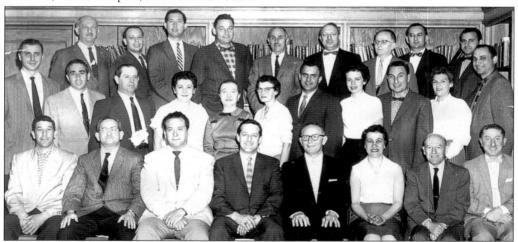

This board of directors of the Jewish Community Center of Greater Lynn served from 1957 to 1958. From left to right are the following: (front row) Bernard O. Bloom, Harold Goodman, Dr. Ezra V. Saul, Barney P. Mazonson, Samuel Backman, Mrs. Joseph Risman, Samuel Sidman, and Jack Chilnick; (middle row) Lawrence Rines, Leonard Lunder, Maxfield Kremen, Mrs. Ezra Saul, Mrs. Sam Schwartz, Mrs. Nathan Fierston, Harry Cohen, Mrs. Shepherd Simons, David Levy, Mrs. Harold Zimman, and Allan Rosenberg; (back row) David Winer, Ernest Siegel, Edward Brown, Ralph Rosenfield, Joseph Golant, Joseph Kalikow, Hyman Addis, Dr. Sidney Taylor, and Robert Smith

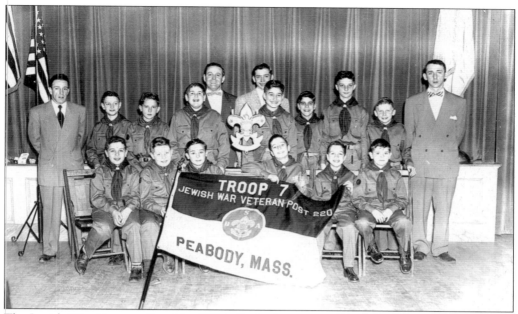

The Jewish War Veterans Post No. 220 in Peabody sponsored Boy Scouts Troop No. 7. Harry Ankeles, Leonard Levy, Howard Kaplan, and Irving Zoll were Scout leaders.

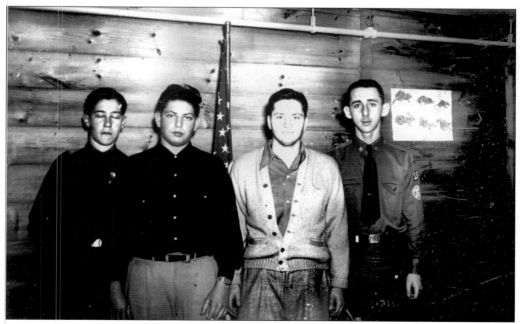

Leonard Nager, Bruce Sachar, Harvey Gladstone, and Irving Zoll of senior explorer Scout Troop No. 19 pose for a photograph at the Jewish Community Center of Greater Lynn in 1949.

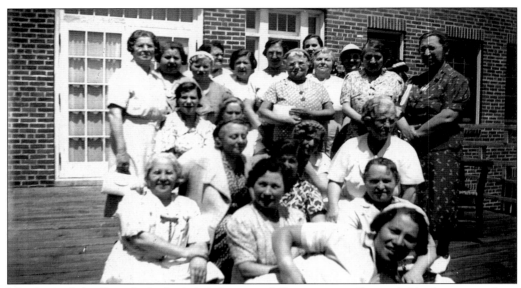

Members of the Beverly Ladies' Aid Society of Congregation Sons of Abraham pose for a photograph in the 1930s.

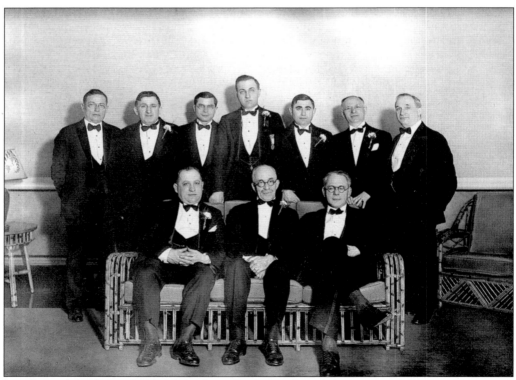

Members of the Salem lodge of the B'nai Brith are, from left to right, as follows: (front row) Nathan Ranen, Leo J. Lions, and Dr. Max Lesses; (back row) Harry Duke, Robert Rogers, Louis Baker, William Berman, Abraham Glovsky, Elihu Hershenson, and Kevin Carman.

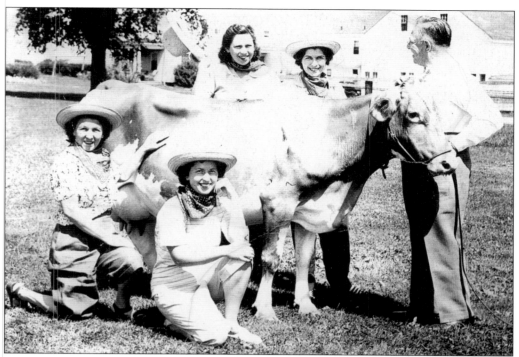

Chairman Hyman Karp and fair committee members absorb the country atmosphere at Hood's Cherry Hill Farm in Beverly during the Temple Israel 1948 country fair. From left to right are Nellie Butman, Gert Zaiger, Natalie Frisch, Sylvia Dine, and Hyman Karp.

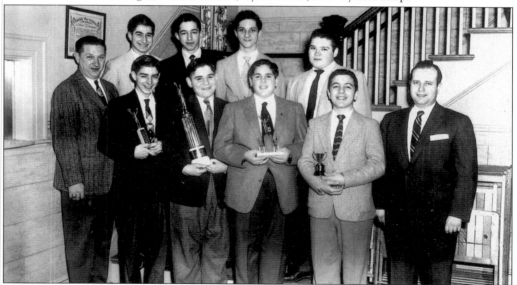

This photograph shows the Louis D. Brandeis Chapter of the AZA, a National Jewish Boys Group in Peabody. The executive board includes, from left to right, the following: (front row) Al Wolsky (advisor), Donald Romo, Michael Ordman, Gerald Wolsky, Arthur Pickman, and Rabbi Dr. Noah Goldstein; (back row) Herschel Clopper, Richard Pearl, Samuel Levy, and Joel Goldman.

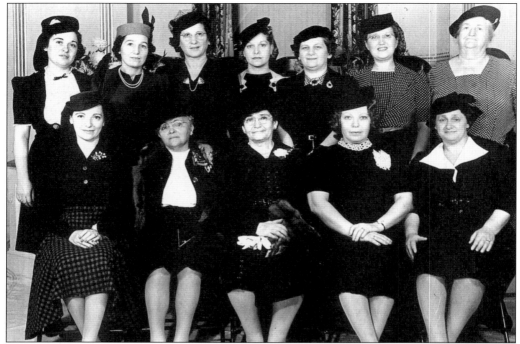

In this *c.* 1925 view, members of the Ladies' Auxiliary of Congregation Sons of Israel are, from left to right, as follows: (front row) Sadie Kirstein, Mrs. Max Korn, ? Strauss, ? Stahl, and Mrs. Jennie Goldberg; (back row) Rose Hershenson, Pearl Herman, Mrs. Abraham Finkleman, Florence Weiner, Sonia Sogoloff, Lena Salloway, and ? Himmelstein.

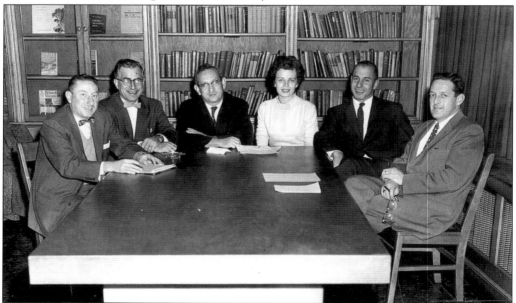

This view of the study committee for the relocation of the Jewish Community Center of Greater Lynn to its new home in Marblehead includes, from left to right, Jack Chilnick, Joe Rosenthal, Harold Goodman, Elaine Simon, Martin Goldman, and Barney Mazonson.

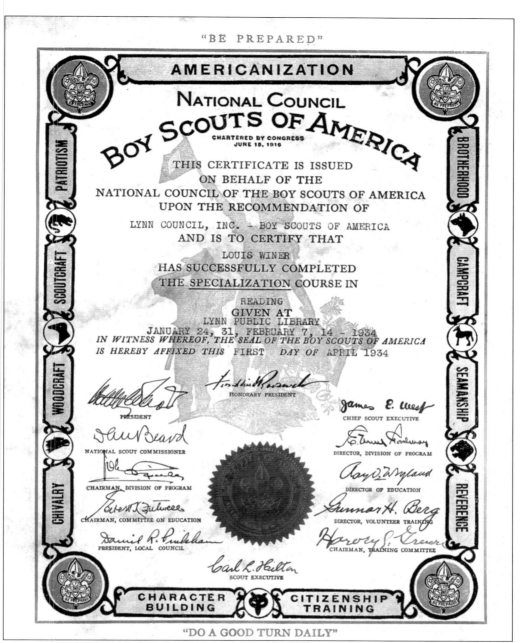

A certificate from the National Council of Boy Scouts of America was issued to Louis Weiner, a member of the Lynn Council of the Boy Scouts of America, in April 1934.

**JEWISH COMMUNITY CENTER
OF GREATER LYNN, INC.**

OFFICERS

Hyman Addis
President
Barney P. Mazonson
Bruce Hamlin
Vice-Presidents
Mrs. Harold O. Zimman
Secretary
Joseph Golant
Treasurer

BOARD OF DIRECTORS

Elliott Adelman
Ralph Alpert
Samuel Backman
Leonard Bana h
Bernard O. Bloom
Mrs. Max Cogen
Harry J. Cohen
Nathan Cohen
James Dokton
Mrs. Nathan Fierston
Mrs. Milton Frisch
Martin C. Goldman
Harold Goodman

Mrs. Bruce Hamlin
Harry W. Hoffman
Dr. David Klickstein
Maxfield Kremen
Frank Levine
Lawrence S. Locke
Joseph Mazonson
Mrs. Abraham Ostrer
Ralph Reback
Mrs. Joseph Risman
Robert Rose
Joseph Rosenthal
Dr. Ezra V. Saul
Arthur Schwartz

Mrs. Samuel Schwartz
Edward Shub
Charles Shulman
Mrs. David Slobodkin
Arthur Sugarman
Dr. Sidney Taylor
George L. Tenenbaum
Philip Waldman
Mrs. Morris Wax
Mrs. Ned White
Jack Winer
Albert Zaiger
Harold O. Zimman

LIFE BOARD MEMBERS

Mrs. Abraham Blumberg
Jack Clebnik

Eli A. Cohen
Benjamin Olanoff

Hyman Prizer
David L. Winer

COMMITTEE CHAIRMEN

Hyman Addis _____ Nominating
Ralph Alpert _____ Endowment
Bernard O. Bloom _____ Purim Carnival
Harry J. Cohen _____ Physical Education
Joseph Golant _____ Jewish Cultural Council
Martin C. Goldman _____ Public Relations
Harold Goodman _____ Golden Age
Bruce Hamlin _____ Budget & Finance
Sonya Hamlin _____ Nursery School
Lawrence S. Locke _____ Adult Activities
Frank Levine _____ Annual Meeting
Barney P. Mazonson _____ Membership
Benjamin Olanoff _____ Personnel
Joseph Rosenthal _____ Administration

Dr. Ezra V. Saul _____ Childrens Activities
Dr. Ezra V. Saul _____ Research
Mrs. Ezra Saul
 _____ Program Evaluation and Training
Edward Shub _____ Recreation
Edward Shub and
 Mrs. Nathan Fierston _____ Blind
Charlotte Slobodkin _____ Teen Activities
Dr. Sidney Taylor _____ Editor, Center News
David L. Winer _____ Camp Development
Philip Waldman and
 Mrs. Nathan Fierston _____ House
Helen Wax _____ Library
Helen Zimman _____ Camp Simchah

STAFF

Walter P. Zand _____ Executive Director
Bernard Liebowitz _____ Program Director
Dov Breskin _____ Program Assistant
Joseph Seigel _____ Program Assistant
Robert Basch _____ Physical Education Director
Robert Francis _____ Recreation Supervisor
Neta Barker _____ School of Dance Director
John Cody, Arthur Smith _____ School of Art Directors
Christine Simmons _____ Head Teacher, Nursery School
Genevieve H. Frenzo, Sally N. Morrill,
Ruth E. Jaffee _____ Nursery School Teachers
Esther Goldstein, Mildred Kaufman,
Patricia Jackson, Jack Polonsky _____ Clerical Staff
Henry Quinn, Frank Parnam,
Wilson Crowell, Ida Paulette _____ Maintenance Staff

LYNN, MASSACHUSETTS

The Jewish Community Center of Greater Lynn program for the 1955–1956 season lists the following activities for juniors ages 5 to 11: Friday Funtime, Sunday Clubtime, Neighborhood Clubs, and Women's League Children's Entertainment Series. For those of ages 12 to 14, the center offered the Tween Club Council, a Charm Series, Social Dance Class, and Tween Night. For teenagers in high school, there was a youth council, teen lounge, and a full athletic program. The center also had ceramics, painting, and dance classes for adults.

Members of Temple B'nai Abraham in Beverly are, from left to right, George Chansky, Max Rubenstein, Henry Glovsky, George Goldberg, Herman Kravetz, and Al Freeman.

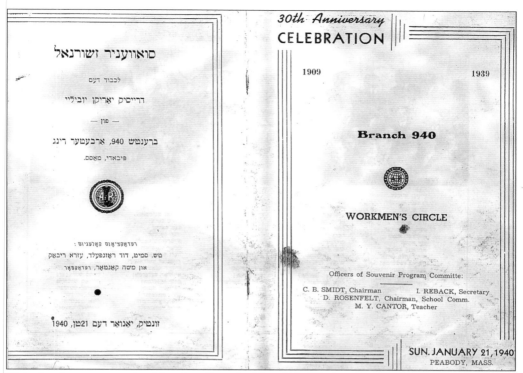

סואוועניר זשורנאל

לכבוד דעם

דרייסיק יאריקן יוביליי

— פֿון —

ברענטש 940, ארבעטער רינג

פּיבאדי, מאסס.

רעדאקציאנס קאמיטעט:

מש. סמיט, דוד ראזנפעלד, עזרא ריבאק

און משה קאנטאר, רעדאקטאר

זונטיק, יאנואר דעם 21טן, 1940

30th Anniversary
CELEBRATION

1909 1939

Branch 940

WORKMEN'S CIRCLE

Officers of Souvenir Program Committe:

C. B. SMIDT, Chairman I. REBACK, Secretary
D. ROSENFELT, Chairman, School Comm.
M. Y. CANTOR, Teacher

SUN. JANUARY 21, 1940
PEABODY, MASS.

This is the program booklet for Branch No. 940 Workman's Circle 30th anniversary celebration on January 21, 1940, in Peabody.

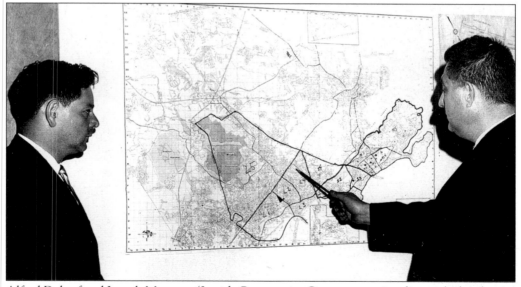

Alfred Dobrof and Joseph Moseson (Jewish Community Center executive director) plot the site for the relocation of the center to Marblehead in 1965. The center, which is now located on Community Road, provides a gymnasium and exercise center, indoor and outdoor swimming pools, tennis courts, meeting space, and classrooms for a wide range of educational, cultural, and social activities.

This fashion show at the Jewish Community Center was sponsored by Peggy's Style Center of Peabody. The participants are, from left to right, Joyce (Rosen) Green, unidentified, Peggy Ward, Sonia Weitz, and Fran Smidt.

Six

CIVIC AND
PROFESSIONAL LIFE

Dr. Meyer Winer was the first Jewish dentist in Salem. Winer maintained an office at 70 Washington Street in Salem, following his graduation from Harvard Dental School in 1912. (Courtesy Dr. Richard Winer.)

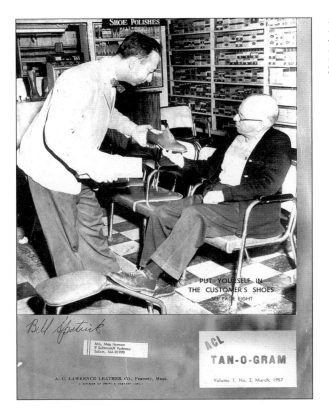

In this 1951 view, Bill Spatrick waits on Stewart W. Miller at Herman's Boot Shop, at 137 Main Street in Peabody.

HERMAN'S BOOT SHOP
Announcing their
Nineteenth
Anniversary Sale

HARRY

MAX

Because you are a valued Herman's customer, we send you this notice to give you an opportunity to take advantage of our Sale Prices.

We offer our entire line of dependable footwear-, nothing changed but the price.

HERMAN'S BOOT SHOP.

This postcard from Herman's Boot Shop announces an anniversary sale on July 22, 1937. Harry and Max Herman operated the shop, located in Peabody Square, for many years.

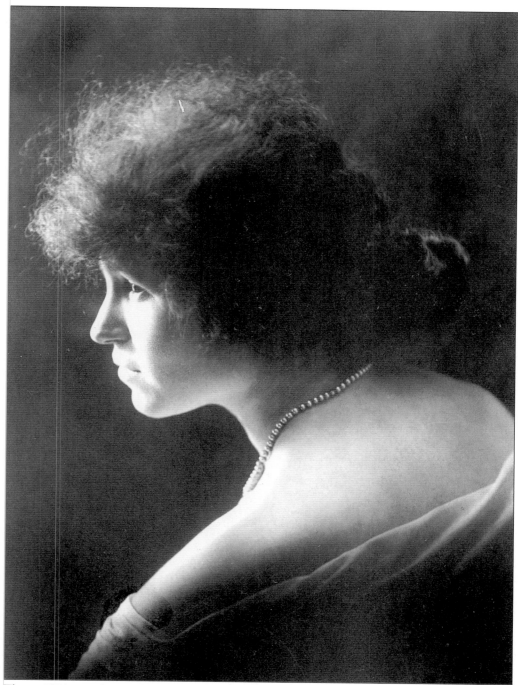

This *c.* 1921 view features Eva Cohen, proprietor of Eva's Hat Shop, on Central Street in Salem.

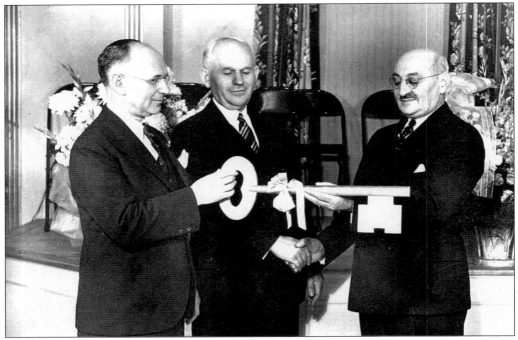

The inauguration of Peabody Hebrew School, at 42 Washington Street, took place in 1939. From left to right are M.P. Stone, Elihu Hershenson, and Max Korn.

Mr. and Mrs. Max Korn, of Peabody, celebrate their 55th wedding anniversary in 1957 at a dinner honoring their service to the Peabody Jewish community.

Abraham Ankeles is shown on the occasion of his appointment as judge of the Peabody District Court. In attendance are, from left to right, Harry Ordman, Sam Pearl (lawyer), Phillip O'Donnell (mayor), Abraham Ankeles (judge), Edward Meaney (future mayor of Peabody), and Moe Goldstein. Ankeles served as city solicitor during the O'Donnell administration.

This *c.* 1920 photograph shows Jacob Hershman, proprietor of Hershman's Variety Store, located on the corner of Blossom and Alley Streets in Lynn. (Courtesy Doris Gilberg.)

Salem, Mass., Apr 7 1908

Mr Gold Shtein

Bought of I. WINEAPPLE & CO.

DEALER IN

COAL & WOOD

HAY AND GRAIN

Terms Cash

14 MILL STREET

| Mar 21 | ¼ | ton coal | — | 1 | 80 | | |

This bill of sale for a quarter ton of coal from the I. Wineapple and Company, at 14 Mill Street, Salem, is dated April 7, 1908.

These advertisements are from the Modern Umbrella Company, at 122 Boston Street in Salem, and the Salem Kosher Meat Company. The latter, for an order to a Mr. Goldstein, is dated May 29, 1908.

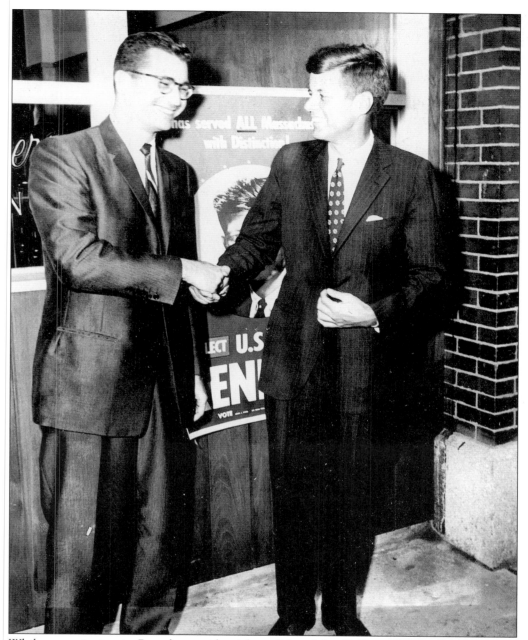

While campaigning in Beverly, presidential candidate John F. Kennedy met lawyer George Chansky in front of his law office on Cabot Street. Chansky was a member of the Beverly Democratic Committee, and Kennedy was on his way to a campaign appearance at the United Shoe Machinery Corporation in Beverly.

Members of Temple B'nai Abraham in Beverly are, from left to right, David Gordon, Jordan Katz, and Jack Weisman.

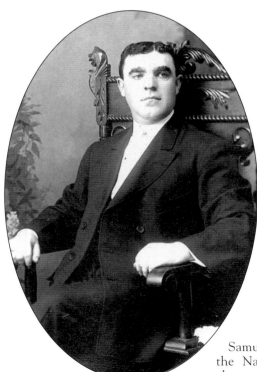

Samuel Kerr and his brother Joseph operated the National House Furnishing Company, located on the corner of Washington and Derby Streets in Salem.

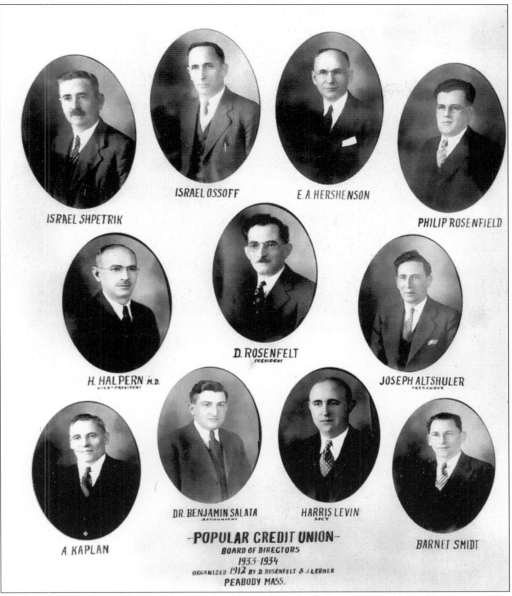

ISRAEL SHPETRIK

ISRAEL OSSOFF

E. A. HERSHENSON

PHILIP ROSENFIELD

H. HALPERN M.D.
VICE-PRESIDENT

D. ROSENFELT
PRESIDENT

JOSEPH ALTSHULER
TREASURER

A. KAPLAN

DR. BENJAMIN SALATA
ACCOUNTANT

HARRIS LEVIN
SEC'Y

BARNET SMIDT

-POPULAR CREDIT UNION-
BOARD OF DIRECTORS
1933-1934
ORGANIZED 1912 BY D. ROSENFELT & J. LERNER
PEABODY MASS.

This montage shows the Popular Credit Union board of directors in 1939. Known as "the auxia," the Popular Credit Union (located in Peabody) catered to Jewish families, although not exclusively. Its board included many prominent Jewish businessmen and other professionals, including Elihu "Al" Hershenson, the first Jewish lawyer and city solicitor of Peabody.

Dr. Donald A. Roos, Saugus's first Jewish dentist, maintained an office at 311 Central Street. His family lived upstairs until 1952. Dr. James Hazlett, his son-in-law, still practices dentistry at this location. (Courtesy the Hazlett family.)

Dr. Donald A. Roos, Eleanor Roos, and Elaine Roos Hazlett are shown in July 1941. (Courtesy the Hazlett family.)

Dr. Harry Halpern, the first Jewish doctor in Peabody, lived at 39 Central Street. Halpern maintained an active practice for many years serving the Peabody community. His daughter Doris Schwerin's book *Diary of a Pigeon Watcher* contains many vignettes of Peabody history.

Dr. William Leibman makes house calls. Leibman, a Yale graduate, was the first Jewish doctor

in Lynn and had an office at 180 Summer Street.

Dr. Hyman Yudin was the first Jewish doctor in Beverly. Yudin was a member of the staff of Beverly Hospital and maintained an office at 497 Rantoul Street, Beverly, until his death in 1942. He was a general medical doctor and a graduate of Middlesex Medical School.

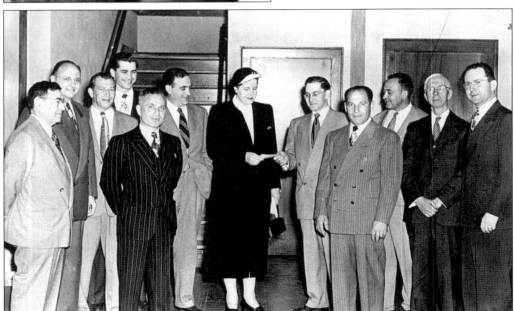

The Beverly lodge of the B'nai Brith presents a gift to Beverly Hospital at the Beverly Community Center on Bow Street. In attendance are, from left to right, Abraham Glovsky, Dr. Erwin Brodsky, Dr. Samuel Albert, George Chansky, Dr. William Goldberg, Dr. Jacob Fine, Mae Bartley, Jack Weisman, Samuel Weinberg, Dr. Richard Alt, Mayor Robert J. Rafferty, and Rabbi Meir Engel.

Seven

RECREATIONAL AND SOCIAL LIFE

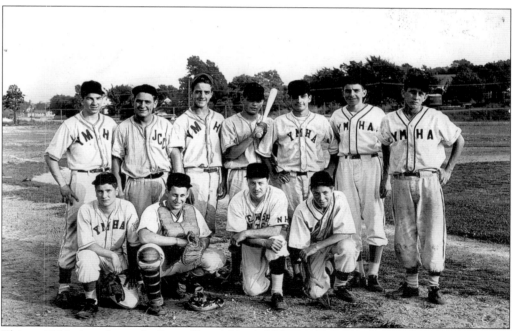

This c. 1954 view shows the Lynn Young Men's Hebrew Association (YMHA) baseball team. From left to right are the following: (front row) Murray Servetnick, unidentified, Morris Levine, and Jason Beden; (back row) Dick Callum, Charlie C. Goodman, Alan Lanes, and four unidentified players.

In 1926, the second home of the YMHA was at 18–24 City Hall Square in Lynn. The YMHA was formed in 1911 by five men—David Haskell, Abraham Haskell, Israel Margolskee, Benjamin Musinsky, and Charles Goldman. The YMHA initially met at Congregation Ahabat Shalom, formerly located on Church Street in Lynn, then at a rented space at 120 Market Street in 1913.

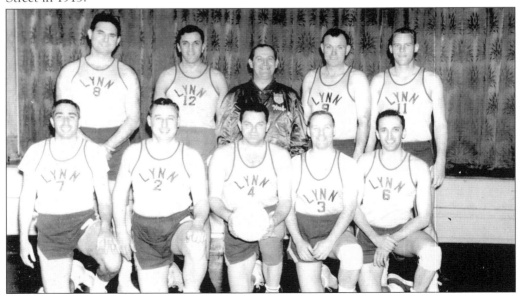

This is a photograph of the men's basketball team of the Jewish Community Center of Greater Lynn. As the YMHA in 1911, and later as the Jewish Community Center, the center on Market Street was a focal point for Jewish activities on the North Shore. The center moved into its Marblehead home in July 1972.

Morris Levine was a member of the championship baseball team of the Jewish Community Center of Greater Lynn, one of the many athletic teams that competed on the North Shore and elsewhere.

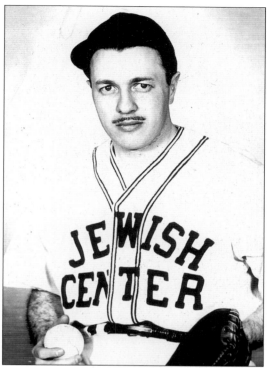

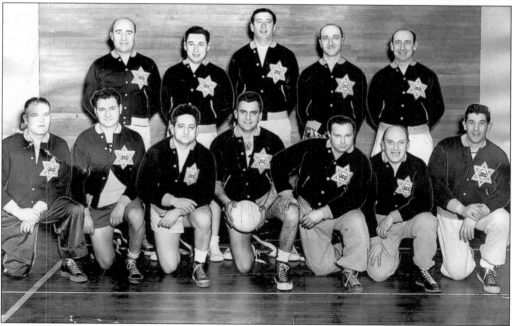

The Jewish Community Center of Greater Lynn's volleyball league is shown here c. 1946. From left to right are the following: (front row) Phil Waldman, Bennie Goodman, Harold Goodman, Harry Cohen, Eddie Shub, Joseph Milman, and Barney Bloom; (back row) Irving Farber, Frank Goldman, Sam Alper, Ralph Denenberg, and Lloyd Castleman.

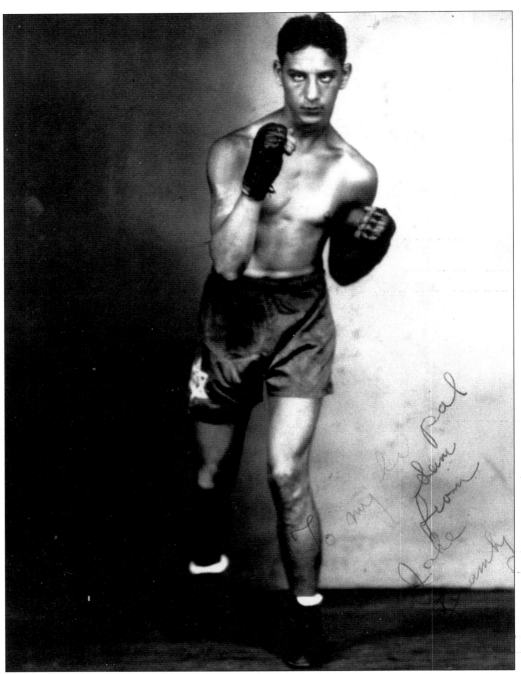

Jake Zaremby was known as Lynn's golden boy. Zaremby fought his way into the ranks of top-notch fighters in 1928 and 1929. In 1928, he defeated the world featherweight champion, Andre Routis, in a nontitle bout at the Boston Garden. After retiring from the ring, Zaremby became an employee of General Electric and an official of Local 201 of the United Electrical Workers' Union. He also conducted boxing classes. Another well-known Lynn fighter was Abe Wasserman, who fought under the alias "Tom Daley."

In 1955, Jewish Community Center tennis players are shown at the back of the YMCA in Lynn. The center provided many athletic activities and facilities, including basketball, volleyball, and a gymnasium.

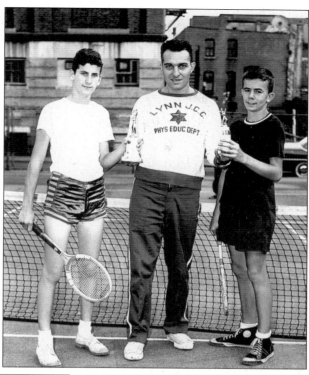

A counselor demonstrates the batting stance at Camp Brunswick.

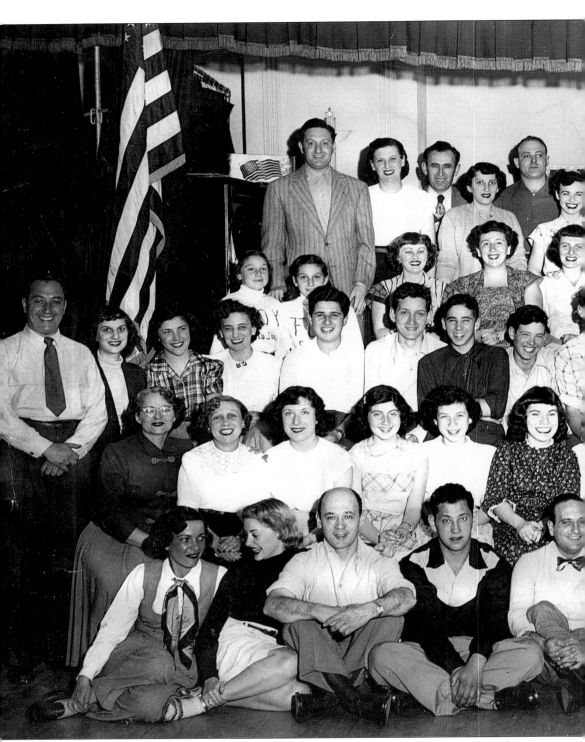

The Jewish Community Center of Peabody put on a minstrel show in 1950. The center frequently presented elaborate entertainments, which not only raised funds for the center's

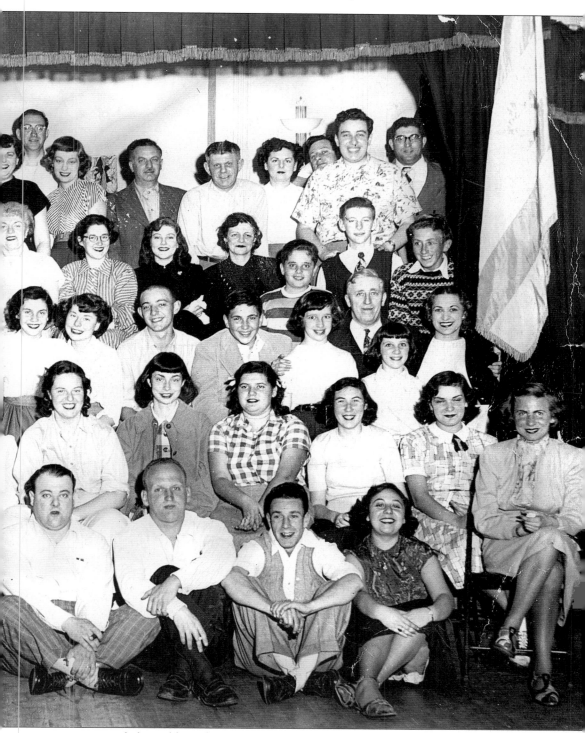

many activities and charitable endeavors but also served to unite the community.

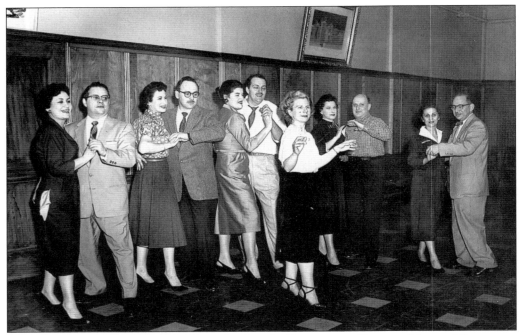

Cha-Cha dance classes were held at the Jewish Community Center of Lynn. The center provided a wide variety of classes and lectures, as well as clubs and organizations for all ages, including many after-school programs for children.

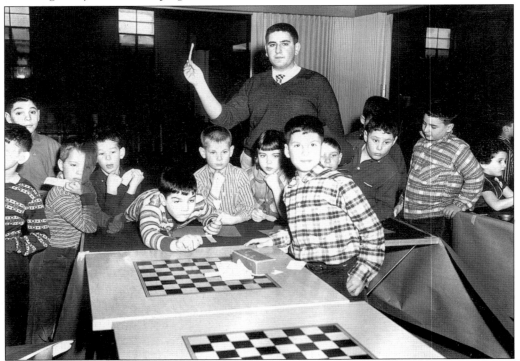

Children play games in the children's department of the Jewish Community Center in Lynn.

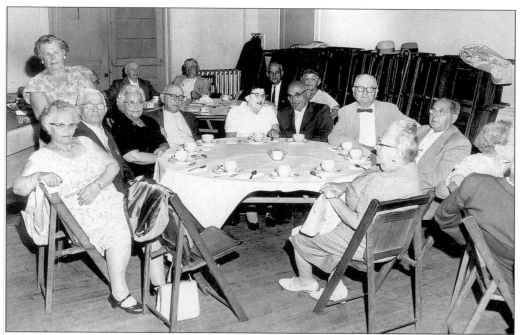

This photograph shows the Golden Age Group of the Jewish Community Center of Greater Lynn in September 1962.

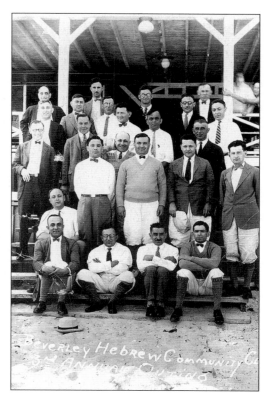

The Beverly Hebrew Community Center's third anniversary outing took place in Old Orchard Beach, Maine, on August 12, 1925.

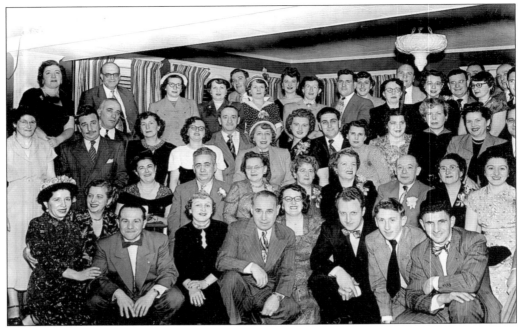

The Linsky-Morris Cousins Club held its annual dinner at the Wiley House, Swampscott, in 1950. The club met regularly for many years. It hosted outings and picnics in the summer, as well as Hanukkah parties.

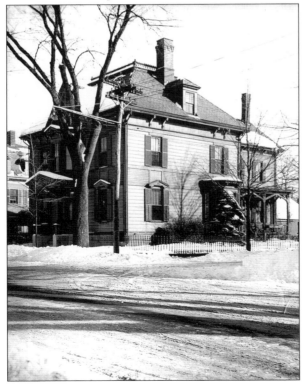

The original home of the Peabody Jewish Community Center was located on Washington Street in Peabody. This photograph shows the original wooden building before it was redone in brick. The center opened in 1939 and became the center of Jewish cultural and social life in Peabody. It closed in the 1970s, when much of the Jewish population shifted to West Peabody. Another community center opened in 1979 in West Peabody. It is now known as the North Suburban Jewish Community Center.

CLARK C. GRIFFITH
PRESIDENT

WILLIAM M. RICHARDSON
VICE-PRESIDENT

EDWARD B. EYNON, Jr.
SECRETARY

WASHINGTON AMERICAN LEAGUE
BASE BALL CLUB

OFFICES: 7th ST. AND FLORIDA AVE. N. W.
WASHINGTON, D. C.

TELEPHONES: NORTH { 2707 2708 2709

December 16, 1929.

Mr. Edward Wineapple,

291 Lafayette Street,

Salem, Mass.

Dear Sir:

The Washington Club will exercise it's option contained in your 1929 contract for your services for the season of 1930, and will shortly forward you a contract in respect to your services and salary for 1930.

Yours very truly,

Clark Griffith

President.

This letter from the Washington Nationals American Baseball League team president, Clark Griffith, to noted Salem athlete Eddie Wineapple offers him a contract for the 1930 baseball season. Wineapple, a member of a prominent Salem family is regarded as one of the North Shore's most accomplished athletes.

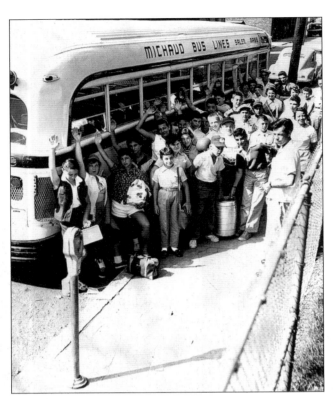

Summer campers prepare for an outing at the Jewish Community Center of Greater Lynn.

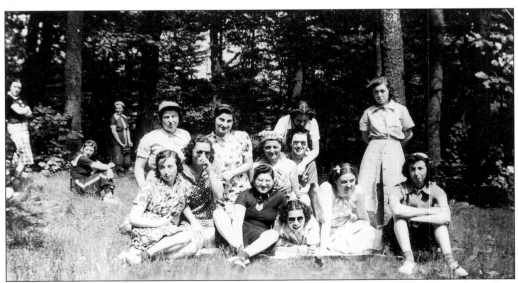

Among those enjoying the summer picnic are, from left to right, Lillian Gorfinkle, Sadie Fisher, Rose Pekin, E. Houdash, Florence Gorfinkle, Anne Pekin, Ida Gorfinkle, Ida Leamon, Fannie Gordon, Bessie Shapiro, Sarah Frager, Alice Komarin, and Sophie Loss.

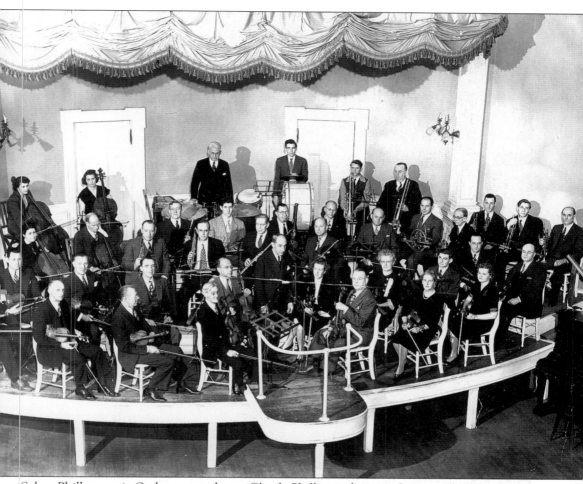

Salem Philharmonic Orchestra conductor Claude Phillips is shown in January 1947. Dr. Meyer Weiner (front right) plays the violin, as does Sidney Altshuler of Beverly.

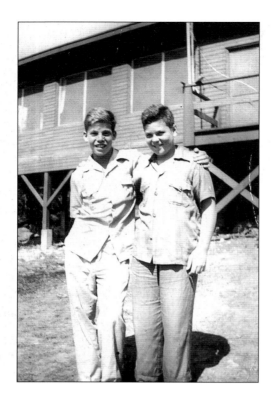

Richard Winer and Saul Axelrod are shown at Camp Young Judea in 1941.

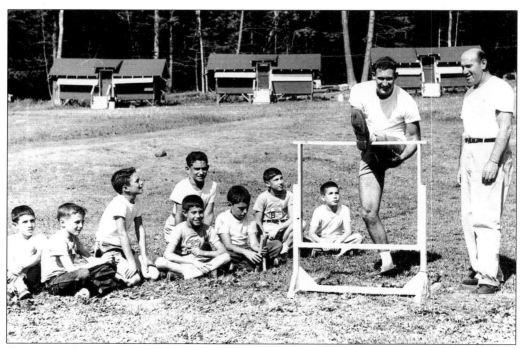

Campers and instructors are shown at Camp Brunswick.

124

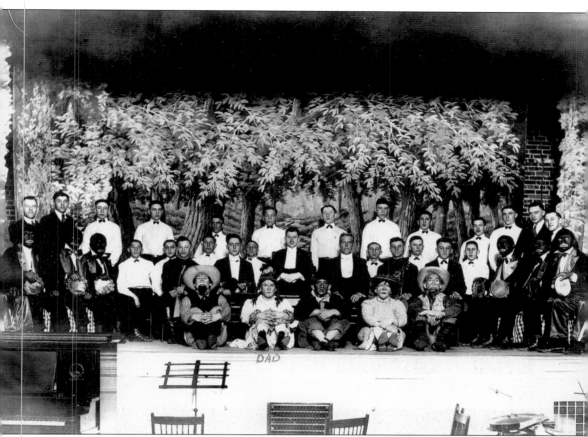

The YMHA puts on a minstrel show at the Jewish Community Center on Market Street in Lynn.

These people enjoy a summer picnic on July 4, 1919.

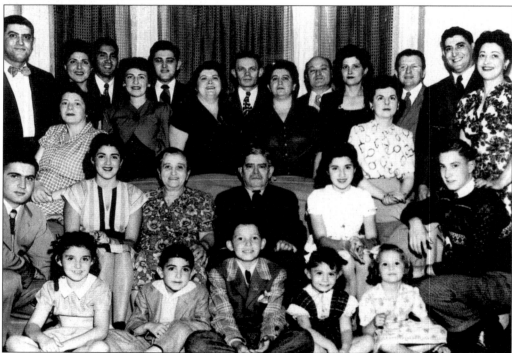

This *c.* 1946 Zeitlan-Zetlan family photograph shows the children and grandchildren of Abraham and Etta Zeitlan of Church Street, Lynn. (Courtesy Doris Gilberg.)

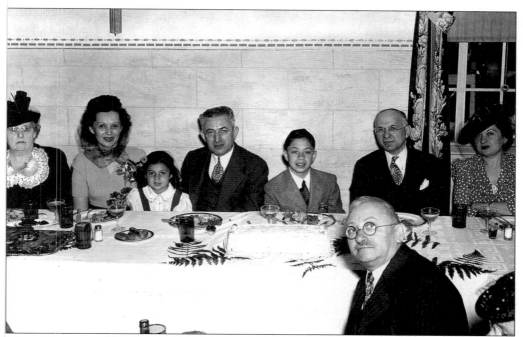

Meyer Kirstein and his family were prominent in the Peabody Jewish community.

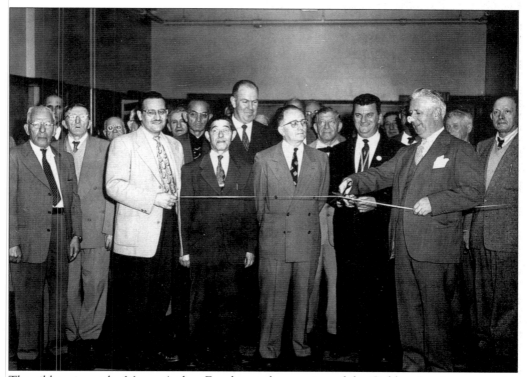

The ribbon is cut by Mayor Arthur Frawley at the opening of the Golden Age Lounge at the Jewish Community Center of Greater Lynn.

ACKNOWLEDGMENTS

The authors acknowledge with thanks the following individuals and organizations that have helped in the research of this book and that have provided photographs, information, and support: Dr. Alan Radack, president of the Jewish Historical Society of the North Shore—without his assistance, this project would not have come to fruition; Sandy Weinstein for all her valuable assistance; Dr. Richard Winer, past president of the historical society; the members of the board of directors for their support of this project and for their dedication to the preservation of our Jewish history; Cliff Garber; Bob Moulton; Ray Wallman for his gift of the Ray Wallman Collection to the society; Peabody Historical Society; George Peabody House Civic Center; Peabody Institute Library; Elaine Israelsohn of Temple B'nai Abraham; Doris Gilberg; Morris Miller; Alan Samiljan; Bob Lappin; Evelyn Kublin; Carl and Sylvia Pierce; Edith Pierce; Milton T. Zorch; Barrie Stein of Temple Beth El; Maxine Levy of Temple Beth Shalom; Bette Wineblatt Keva; Helaine Hazlett; Mark Arnold; the late Nathan Gass for *The Jews in Lynn: A Retrospective* (1987); the late M. Irving Herbster for his *Peabody's Jewish Community* (1968); Marblehead Historical Society; Doris Feldman; Evan Panich for his assistance; and most especially Linda Pesco for her word processing skills and her diligent and patient typing. Thanks also go to all those who contributed to this book and who have not been named specifically.

Alan S. Pierce would like to thank his wife, Donna, for her encouragement and aesthetic contributions to this book.

Avrom J. Herbster would like to thank Merrill Zafran, Matt, and Jeremy for their love and support, Congregation Sons of Israel, and the Schateau Group.

This book is meant to depict the history of the Jewish community of what is commonly referred to as the North Shore, from the 1890s to the 1960s. It is not meant to be complete or to encompass all organizations and people. We apologize, in advance, for any errors of fact or omission.